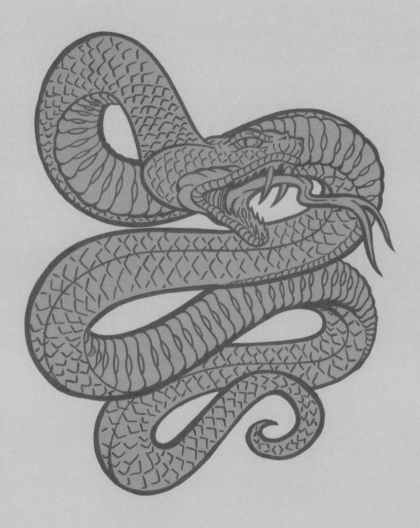

JUSTICE HOWARD'S

VOODOO

WRITINGS BY VOODOO QUEEN BLOODY MARY

CONJURE AND SACRIFICE

Schiffer Publishing Ltd

4880 Lower Valley Road • Atglen, PA 19310

This book is deliciously dedicated to
JOHN GILMORE and BLOODY MARY

CONTENTS

FOREWORD

JOHN GILMORE

Yearning for a sacred place in a space where nothing is sacred, to live against the glassy cool skin, the scented loins smelling of an orchard or crushed green leaves; the taste of raw string bean, the smell of horse sweat and a saddle or like the whining, vibrating power of an engine carrying me faster, soul trailing in a stretch of waves like velocity in a comic book. Justice Howard's magic eye scrutinizes the heart of this heat. She knows the Vegas sun and the L.A. rains, knows the indigo ripples of evening and the tide sucking at the shore. She knows the lightless core of night—she's been there and knows its blind embrace. She's done it all and her life's now a glass funnel, her power tapered into the shaved tip—that narrow concentration that reflects the best of today's fine artists.

She knows the living landscape, can capture the pulse, the cat people with naked eyes, the cable people with electric brains and the celebs, despair lurking in the glint of their shining eye. Her images tug at the mind. You don't even know you're being shoveled into a sort of shrine; a washed, bared, blessed, consecrated tunnel of bewitchment and yearning; a kind of hoodoo merging of body plus soul, not quite stenciled exact so that we're seeing a shred of shadow cast by the bright faces and naked radiance.

Desire is dangerous or languid, fulfilling or temporal. Another route to danger, like I knew in certain girls and women, strong thighs and smooth skin, lips so hot you were sharing a fever. You couldn't help running inside the fire; said to holy hell, mustered all the gut juice, taking the chance.

Beautiful near-naked females stretch and reach so realistically into real life you can almost taste them, caress their breasts, touch their feet and hands, feel the tendons in their arms, their necks The angle of an elbow, the turn of an ankle, an averted eye. She-devils or angels; desire rushes over these shapes and pulls us like violent songs or eager dance partners. We hunger as though these images are not whole without us. Our desire is to fuse with such uncompromising sexuality sculpted by the eye to near-perfection by an astounding artistry. We are one with these images and haunted by the hankering for a union of flesh.

The source of all this celebration dwells in a place nobody can reach. Such a spot is the creative vision of Justice Howard, where the heat of these images snap into being like squalling balls of fire.

We're talking magic. Everyone wants to know how the trick's done so they can do it themselves and be saluted. They can't do it. You're born a genius and it doesn't

She knows angst and pain and fear. It's tracked her like a hound since visions rolled through her child's head like a pinball machine, now leaping before her lens at every moment her eye sees into the fire.

come with a guarantee of ease, or that what you know or where you've driven can be mapped. You go through all the living and dying and changing in this glue-like stew of our cultural mishap, a swilling, polluted society of ever-changing mise-en-scènes. You say go to L.A., you make it or you don't, you exist or perish, taking your best shot in an arena that doesn't care whether you do it or not. Great artists are born. A lot of them don't even know they've arrived. The ones that do, like Justice Howard, learn fast to sing their own song and ride their own horse.

Justice knows it. Not with the knowing of finding your car keys or getting a diploma, but the knowing that's in the blood. It trickles in at the end of the path of most resistance. You pay wicked, nasty dues for your ride through the infiltration course of being an extraordinarily original artist. Sometimes down at the end of the line you get your ticket punched. It says, "This one does what it wants." You do what you want and if you do it with all you are in the time you've got to do it in, as a Zuni shaman told me, you're doing the thing that's next to God and you couldn't ask for one iota more.

Playing God? Hardly. It's creating another reality; another dimension in this flat, paint-by-the-numbers milieu we're crowded into. When you're lucky, God's sticking fingers into your back like the guy with the wooden dummy who opens its mouth, wiggles it's hands and says remarkable things.

Ask Justice. She's seen that movie a lot of times. She knows angst and pain and fear. It's tracked her like a hound since visions rolled through her child's head like a pinball machine, now leaping before her lens at every moment her eye sees into the fire.

We're hungry for what cannot necessarily rise to the surface, but it is there, accelerating between force and energy and glorious sexuality. The wanting and desire for this miracle of creation, even in the eyes, the degree the lid has slid and we're drawn like a sliver of metal to a magnet. Thought, presence; yearning in every untouchable pore and inch of flawless skin, she lays bare before us this rolling, unending sway of a surface continually evading the seeker. Ah! you finally say, "I see what it is—" a mirror of the seeker's secrets, everything we've yearned, wished for. Ah! again, a grand wish-book, a dream-book, packaging the most sensual and captivating pictures to be devoured by the spirit.

Women stalwart like straight out of Wagner's opera, or lithe and svelte with mysterious doe-eyes and personae pushed beyond their years. A sum of illusion celebrating astounding beauty and secret dreams leached from the reality of a homogenized existence. With these vivid, vibrating images reflecting what can more than likely never be held as fact, indeed echoing a heat from the mind of Justice Howard, our spirits are lifted above the level of despair and the possible no longer seems so hopeless. All of this is while driving hard into the night, chasing what cannot be nailed, hunting for what our desire seeks to make real. Justice Howard's genius fills this gap—this mysterious place between a high-speed escape and an indefinable vanishing point.

PREFACE

JUSTICE HOWARD

The idea of Voodoo popped in front of me like a screaming ghost from the dark end of the dank mossy Louisiana swamp. Maybe it came from the Loas or possibly it was Marie Laveau whispering in my ear like the hiss of her erotically winding snakes.

I was bored with a lot of the art that I was creating, desperate for some new "gut juice" as John Gilmore called it. It is inherently fitting that John's spirit is rampant throughout this book because he had a huge amount to do with it. He always told me to stretch my boundaries, and so I have. In stretching them, I chose to actualize this photo series, which took me over two years to complete.

I have always been taken with the darker side of things. My personal visits with serial killers and ongoing friendship with John Gilmore, author of *Severed: Story of the Black Dahlia*, is testament to this fact.

Let me state here that John Gilmore was my "planet man." He was always and will forever be my favorite man on the planet, and I miss him dearly every damn day.

A modern Voodoo photo series on this complicated, often misconceived religion has never been done like this before, so I knew I would need some heavy hitter Voodoo backup.

I reached out to Bloody Mary, the Voodoo Queen of New Orleans, and asked her if she'd like to be a part of it. Bloody Mary is also an author, psychic medium, and the Voodoo practitioner they called in during the filming of *American Horror Story* to do banishings on the set to rid it of all of the negative paranormal activity they accidently conjured up. Mary gives award winning graveyard and paranormal tours and is also the curator/owner of the New Orleans Haunted Museum. Mary teaches you how to connect with (or protect from) the many supernatural worlds around us. She even helped me channel a Voodoo spirit during my self-portrait for this book. Her insights give the project an insider's Voodoo touch as well as an accuracy that not many people could provide.

This photo series houses real bones and Voodoo relics. The skulls featured are also real human skulls originally used in Santeria rituals. All of the animal remains, like the pigs' heads, are real. The models are also real and I handpicked and styled them for the photos you see before you.

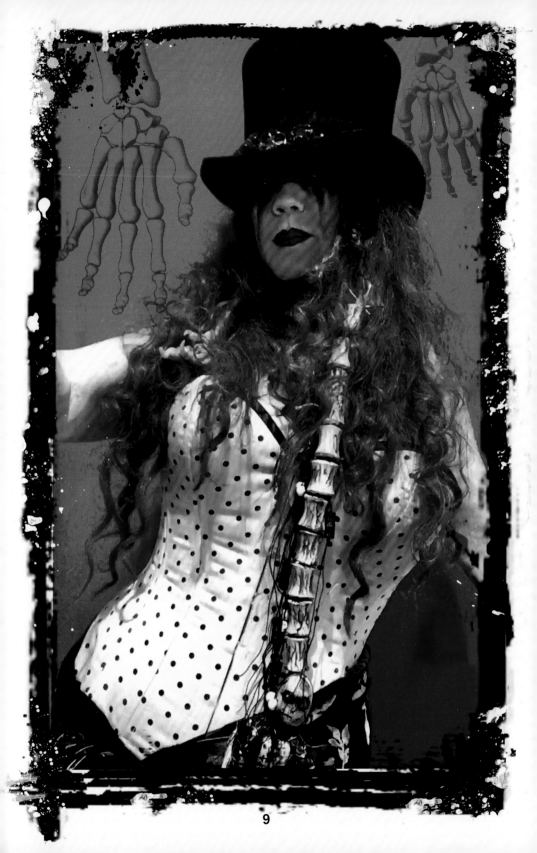

> Enter that "not to be," of the betwixt and between, where
> lay the mysteries, the spirits, the Loas or Voodoos. These
> are the many names for the intermediary spirits or
> Voodoo saints.

INTRODUCTION

BLOODY MARY

If a picture is worth a thousand words then the work of Justice Howard deserves tens of thousands. But Justice serves up more than words. She gives us art and when we peel back the layers to expose the core, we might actually find revelation.

Justice Howard also gives us meaning through word. The main word is the most provocative: Voodoo. Only the Spirits can truly tell us why this book is titled so, and perhaps it is simply the word itself which answers the why.

Voodoo is an African word of the Fon/gbe language group and it translates to mean "spirit or spirit force." It is in this way that this book and Justice herself is Voodoo; for she too is a force to be reckoned with.

Many only know of Voodoo from formula Hollywood movie scripts and pulpit preachings of mainstream religions, but the difference here is that Justice's eye is unique and her small town *is* Hollywood.

Yes, Voodoo is a religion: misunderstood and maligned, ancient and wondrous. Justice does not come from inside the religion of Voodoo or even from a strictly Hollywood Voodoo view but is caught somewhere in between. She is a modern, independent, constantly-questioning-the-worlds, bawdy woman built around an artist's soul, who gives us her version of Voodoo—Voodoo Justice-style.

An icon of the Hollywood scene herself, Justice is also a product of her environment, graduating with a major in Hollywood horror films, raw rock band shock imagery, and an allure of instant gratification of fantasy Voodoo, with its dark halo of maleficent motive and an entire antiestablishment posse.

Hollywood weaves a dark and fearful cloak which it wraps around the word Voodoo, a word which in and of itself evokes sinister images to all but a few. Yet the reality of my chosen religion is truly shamanistic in tone: trance-dance possession carrying animistic subtleties, holding tight to its reverent ancestral spirit base and dipping and twirling with a deity-rich embrace. Voodoo is not a collection of spells and hexes to make people bend to your will the way Hollywood, and a few pains in the ass I know, try to paint it.

Voodoo is scapegoat or savior, depending on which end of the lens you are looking through. And now you too can see it from behind the lens of the one and only Justice Howard: woman warrior, artist, and the true epitome of bosale. Bosale is a term for the untamed and a Voodoo term given to the uninitiated: Visualize a neophyte entering the Voodoo arena, she bucks and fights to keep her own, to make her mark and hold it strong. This is the Voodooiene who has not taken to the sweet surrender of possession. We all fight to "be" and are trained to not let others "break us" but it is in this wallow

Pamela Reed photo.

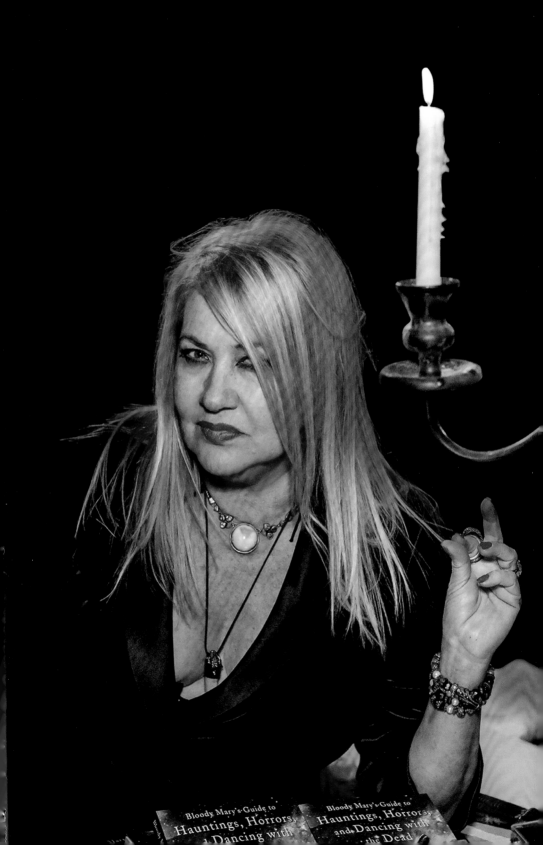

Bloody Mary's Guide to
Hauntings, Horrors,
and Dancing with
the Dead

of surrender to something bigger than yourself that you become. Enter that "not to be," of the betwixt and between, where lay the mysteries, the spirits, the Loas or Voodoos. These are the many names for the intermediary spirits or Voodoo saints. The word *loa* comes from the French word for "law," the *mysteries* are what they are, and the voodoos with the small *v* is another way to categorize these angels in the pantheon.

Justice reached out to me for reasons other than she thought; not just to write this book but for the mirror I carry and teach through. Once exposed to the mirror, Justice saw so much more. This is evident in her art. She has her own special vision and her eye is all seeing in this way. This is Justice's gift. Her work is raw and naked dipped in an avant-garde philosophical dichotomy of flesh and spirit. Her sacrifice is her sacred touch and devotion. For sacrifice is not about giving up or offering up something—in its root *sacrifice* means to make "sacred," so I went in search of Sacred, Justice style, and found it!

She claims I forced her to take this work more seriously; a work which was at first just a book of her fabulous pictures. Then text and light tales emerged here and there.

If I forced her to dig deeper within her soul for a spirit connection, then I am happy for that is my job as priestess. I am the voice of the spirits. So I added voice to her vision.

But it is the spirits themselves who must have wanted that Hollywood voice to echo "why?" and dig in to speak on and out through these pictures and these thousands of words.

These pictures have thousands of interpretations but they pushed Justice to Voodoo. Maybe this book was her informal initiation, that first step, forcing her to dredge up fears and raise that anger to the surface and face it head on. She had to find her own twilight zone to reach balance between light and dark.

Though some anger and raw confusion pours out of the bleeding heart of this artist there is a different light rising. The light that exposes the dark and meets shadow. Voodoo prompted her to look deeper, research and search more. And I gave a gentle push and sometimes the spirits knocked us both senseless to get their further word rewritten, and we followed suit. We redid, rewrote, reshot, reedited it all once, twice, and yet again. Spirit chooses you, many of you . . . but few listen. Justice listened.

I write this introduction to invite you to meditate on Justice Howard's art without preconception or judgment. Let it flow through you. I also dare you to delve deeper into the true studies on ancient religions that need to be experienced to be understood and have never depended on the written word. I challenge you to look through the shock and chaos to find the beauty and, dare I say, purity of the art before you; and I invite you to question your own beliefs and motives when you approach Voodoo, to open the way for justice.

I am Voodoo Queen in New Orleans Voodoo, carrying the Marie Laveau tradition passed down from Queen Margaret, Queen Rose before her, and countless others. I am Mambo Asogwe in Haitian Voodoo with Mambo Sallie Ann Glassman and Papa Edgar Haitian Voodoo lineage before.

I am proud that my initiations were in my hometown of New Orleans since my bloodline here holds from 1718. My dedication to the land, the people, and the spirits here flow through my service with the river who stands at the head of New Orleans Voodoo altars. We sing praise to her as Maman You, as La Sirene, and as the mother of many of the native American tribes along the Mississippi River. Our Maman You is

shown as the upper body of a woman and extremities of a snake or a fish, and *is* New Orleans. I serve as her avatar and as psychopomp with the ancestors to reach out to each and every one of you. I am student. I am teacher and I introduce people to Voodoo every day as a living spirit guide in New Orleans. I must sometimes reflect also upon Hollywood and movie references to help people understand. It is a valid point of comparison since for many, it is all they know.

Many scholars believe Voodoo to be the world's oldest religion. Its ancient African lineage goes way back, as far as man itself. Voodoo traveled to the new worlds with the slave trade, Voodoo is a survivor religion. Voodoo is a musical religion. Voodoo is a danced religion. It learned much upon its journey. I hope that you learn much on yours.

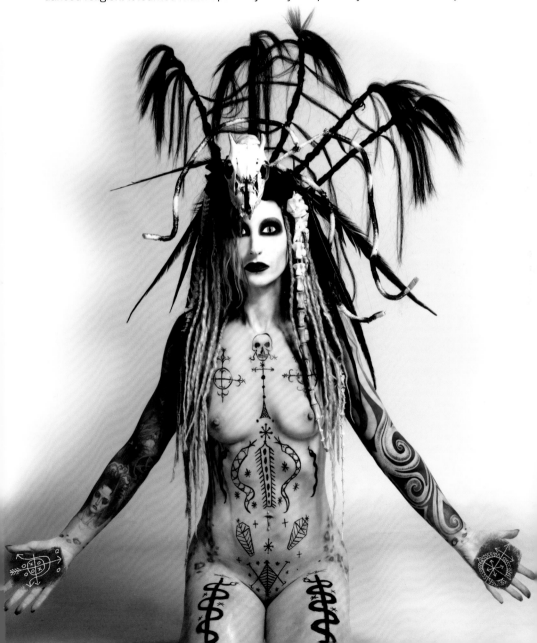

LA SAINTE VIERGE

The Voodoo virgin is known as "La Sainte Vierge." New world Voodoo is influenced heavily by Catholicism, for it was in the Catholic colonies that Voodoo evolved.

The African Voodoo religion mixed with the Catholicism that was forced on the slaves. But the slaves found beauty in the correspondence between Catholicism and their own faith. In Voodoo too, there is one supreme God as well as Voodoo angels. The Catholic saints were adopted by the early Voodoos who found a way to honor both their own intermediaries and the Catholic saints, especially Mary, at the same time. They recognized the deeper meaning in the correspondences.

The truth is that Voodoo is a religion, a philosophy, and a way of life for millions around the world. There are as many varieties of Voodoo as there are of Christianity, and they are all valid in their theory. New Orleans Voodoo is her own tradition, as are Haitian Voodoo, Dominican Vudu (Las 21 Divisions), Brazilian Candomble, Palo, Trinidad Orisha, Santeria, Obeah, and of course the Mother—African Voodoo.

Yet Voodoo and Hoodoo are words that conjure feelings of fear and confusion. Visuals of black magic, zombies, and orgies dance in your head! Fears of dark Voodoo dolls, selling your soul to the devil, and evil curses . . .

True Voodoo and Hoodoo are none of that. Too long have we been told what is good and what is evil so people now prefer to search for their own truth. But the truth about Voodoo is amiss when preached only though the Hollywood pulpit, in movies like *I Walked with a Zombie*, *The Serpent and the Rainbow*, *Angel Heart*, *The Skeleton Key*, the James Bond film *Live and Let Die*, and even Disney's *The Princess and the Frog*. These films show sinister underworld outlooks reinforcing fears of the unknown. This is entertaining fiction and it even contains a few historical facts sprinkled on top for credibility, but it ends up doing harm to Voodoo's image.

> The Catholic saints were adopted by the early Voodoos
> who found a way to honor both their own intermediaries
> and the Catholic saints, especially Mary, at the same time . . .
> The truth is that Voodoo is a religion, a philosophy,
> and a way of life for millions around the world.

14

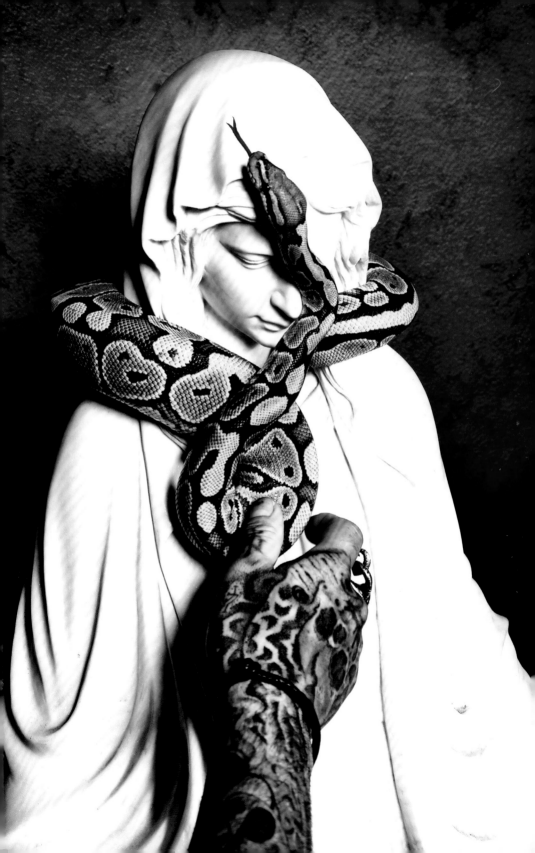

PAPA LEGBA

KEEPER OF THE DOORWAY BETWEEN THE WORLDS

Legba is the doorkeeper and divine messenger between the worlds. The worlds meet at the Crossroads. It is there that prayers are answered, miracles made, and the spirits await; it is there that Papa Legba holds the key to the door to lead you on your path. It is here that all who pass must open the way through Papa Legba. Ayibobo!

Legba is not the trickster that some paint him as, like his crossroads keeper kin in Eshu and Ellegua from neighboring pantheons. And he is certainly not the top-hat-wearing devil that Hollywood costumes him as either. He won't want your baby or your soul but will want your respect and perhaps three pennies.

Legba is the divine messenger and is the important force of sacred movement. He is equated with St. Peter as the gatekeeper and is also similar to Ganesh for he can remove obstacles too. Haitian Voodoo has him as an old man with a cane and St. Lazarus is linked with him. In Africa Legba was a young and agile spirit and in New Orleans Voodoo he still is.

Offerings are kept by the doorways and openings in Voodoo homes and peristyles (temples). When opening a ritual Legba is called on first and the main passages at entrances are saluted and given three drops of water at each portal. You must call Papa Legba, sing or pray, and give offerings to insure his blessing for a smooth passageway for the spirits' arrivals.

The entrances of these Crossroad places are "in-between" places, where this world meets the others. These are places where dimensions are more fluid and where the world is neither here nor there. Legba can connect or even block Voodoo servitors to all other Loas. He is not a simple doorman for he is actually both the door you want to pass and the key itself. He is wise and omniscient. You must come to him dressed in truth.

He is not only the first spirit called up to open Voodoo rituals but also the last called to close them. He loves his rum, cigars, and those three shiny pennies!

In New Orleans the Voodoos were actually called the three-penny people. Three for the trinity and all the many magical ways that number is interpreted. One old meaning of the three was for the ancient trinity: "Mother, Father, Child." And as for the penny part, it was the copper within that mattered hence three pennies for Papa Labas (as we pronounce his name). Copper was worth more than gold on the West coast of Africa from where the origins of Voodoo came. In this gold coast copper was also more rare—and more magical. Copper is used in many mystic ways for it is a base of connection, communication, energy, protection, and healing today. It is a strong and powerful conduit and so is Papa Legba.

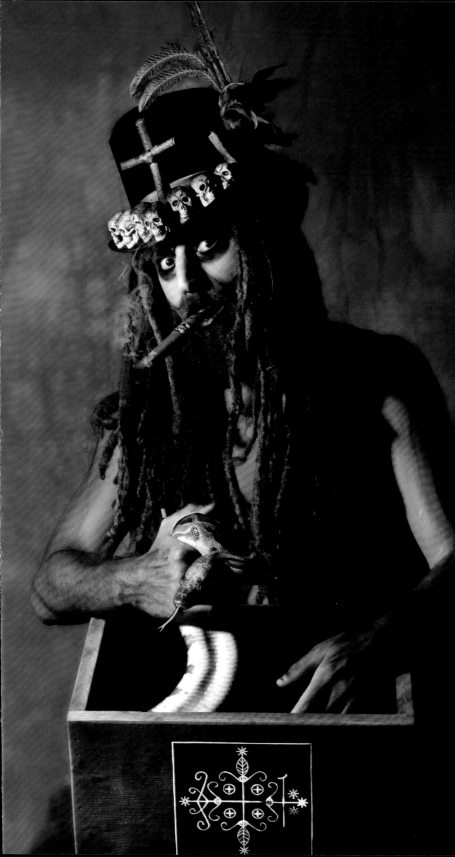

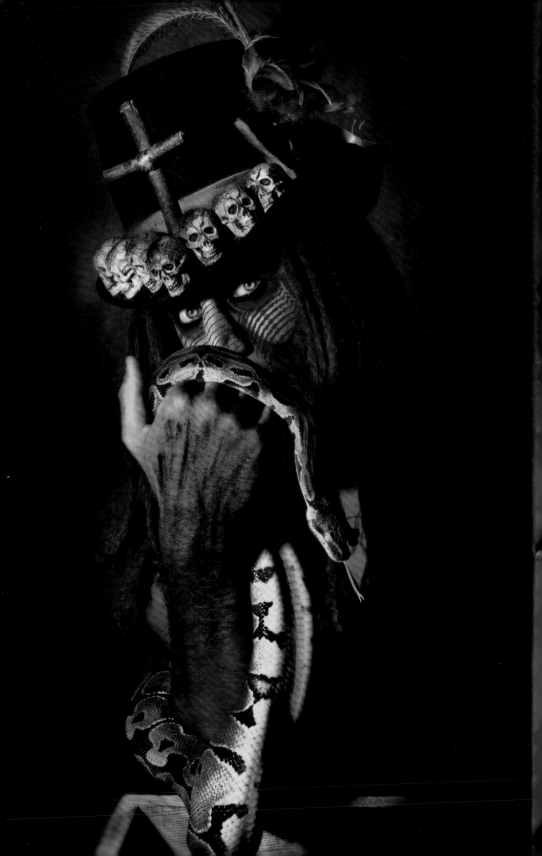

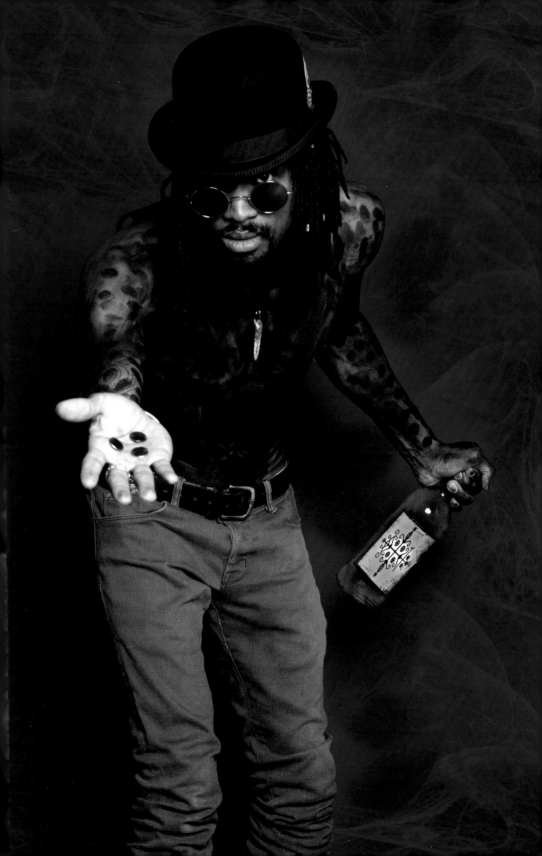

According to legend a young man living on a plantation in rural Mississippi had a remarkable drive and desire to become a great blues musician.

THE CROSSROADS

JUSTICE HOWARD

The legend of Robert Johnson at the crossroads is an old one that many people have heard—and some believe, and some do not. It has been told so many times that no one really knows if the truth persists or if it has gotten lost in time.

The story is well known by all musicians. According to legend, as a young man living on a plantation in rural Mississippi, Robert Johnson had a remarkable drive and desire to become a great blues musician. The story is told that he was instructed to take his guitar to a crossroad near Dockery Plantation at midnight. There he was met by a large black man, whom the story says was the devil, who took the guitar and tuned it. The devil played a few songs and then returned the guitar to Johnson, giving him mastery of the instrument. As the story goes, there was a black dog howling at the time this took place.

In exchange for his soul, Johnson was able to create the blues for which he became very famous. Most reports say that before this he got thrown out of most clubs as he was a horribly bad guitar player.

And so when Robert Johnson, having left his community as an apparently mediocre musician, came back with a clear genius in his guitar style and lyrics, people said he must have sold his soul to the devil. That fits with the old African association with the crossroads, as where you find wisdom: you go down to the crossroads to learn (in Johnson's case, via a pact with the devil). You sell your soul to become the greatest blues musician in history.

According to Bloody Mary, "In New Orleans where the older blues began, it was a sound evolving from the old Congo Square where Voodoo rituals at Sunday slaves' gatherings 'rocked you all night long.' It was Voodoo to blues, blues to jazz, jazz to R&B, R&B to rock 'n' roll, and everyone knows that rock 'n' roll is run by the devil! (LOL.)"

Folklore researcher Harry M. Hyatt wrote that, during his research in the South from 1935 to 1939, when African-Americans born in the nineteenth or early twentieth century said people had "sold their soul to the devil at the crossroads," they had a different meaning in mind. Bloody Mary agrees with what Hyatt claimed: there is evidence indicating remnants of African religious belief surrounding Papa Legba in the making of the "deal."

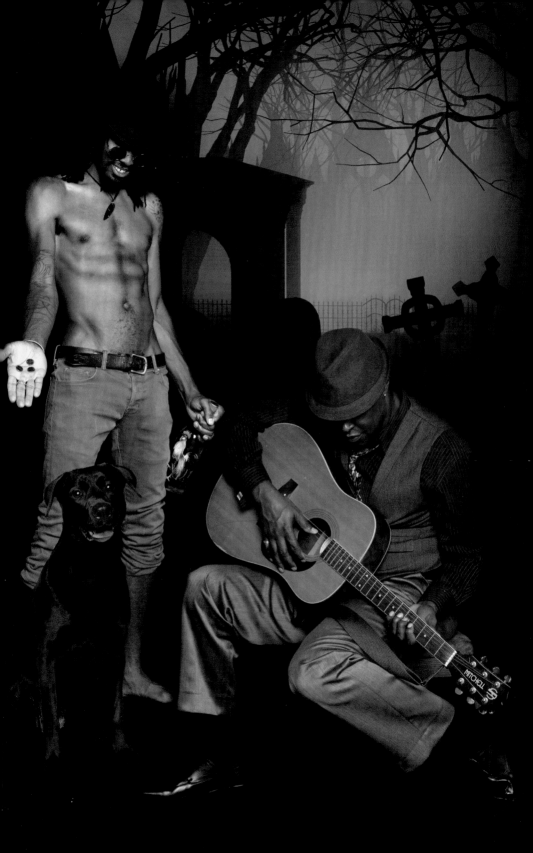

VE-VES, SIGILS, AND OTHER MARKS OF CONNECTION

The beauty of tattoos may only go skin deep, but in religions like Voodoo there is a spirit within that is alive.

Tribal tattoos are marks of connection with spirit, signs of initiation, enlightenment, courage, fashion, and fury. For Voodoo these ritual drawings, or sigil spirit symbols, are known as ve-ves. They are also the perfect art, increasingly seen tattooed on the human body. The ve-ves act as talismans and can protectively adorn ritual items as well as their more well-known ritual 3-D art usually made of cornmeal, gunpowder, or graveyard dirt.

Today some tattoos are recognized for their magico-religious use but more are simply seen as body art. I personally have a Voodoo ritual tattoo of protection and it also serves as body art. Now in this day and age, tattoos are more accepted by the mainstream and are getting increasingly popular as we speak. Most tattoos go unnoticed beyond that veneer of skin deep art, yet secret tattoos are alive with spirit who may be guards and spirit guides all on their own.

We surround Glenn's tattooed hands with ve-ves (see pages 26–27). Glenn's hands may tell a story, filled with layers upon layers of meaning and ancient symbols from the world over to ponder.

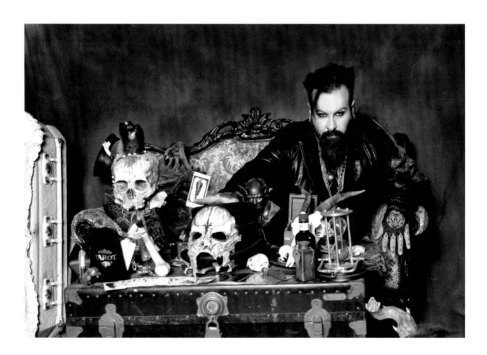

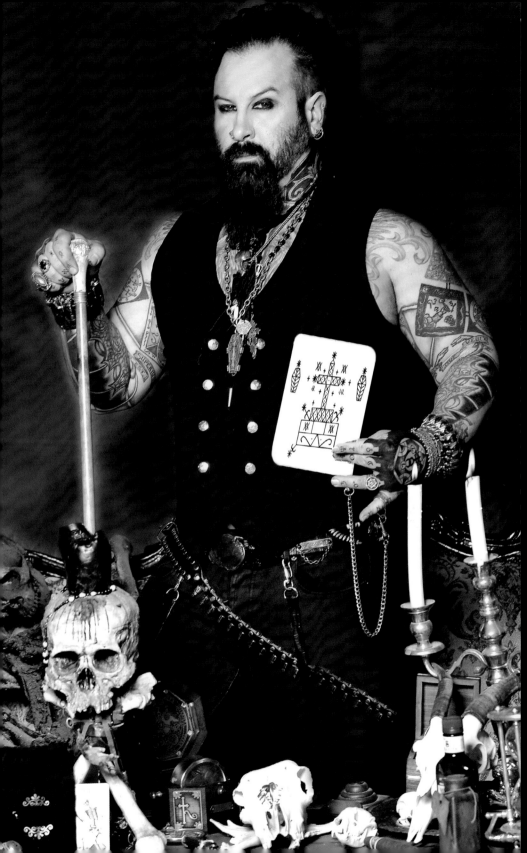

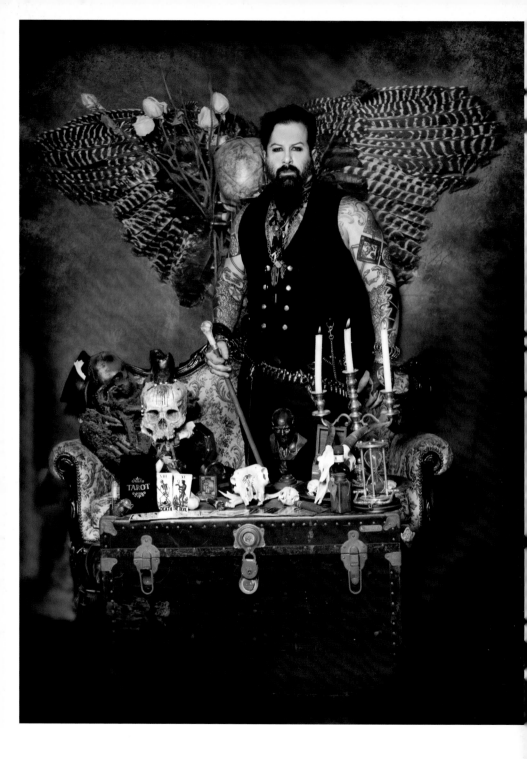

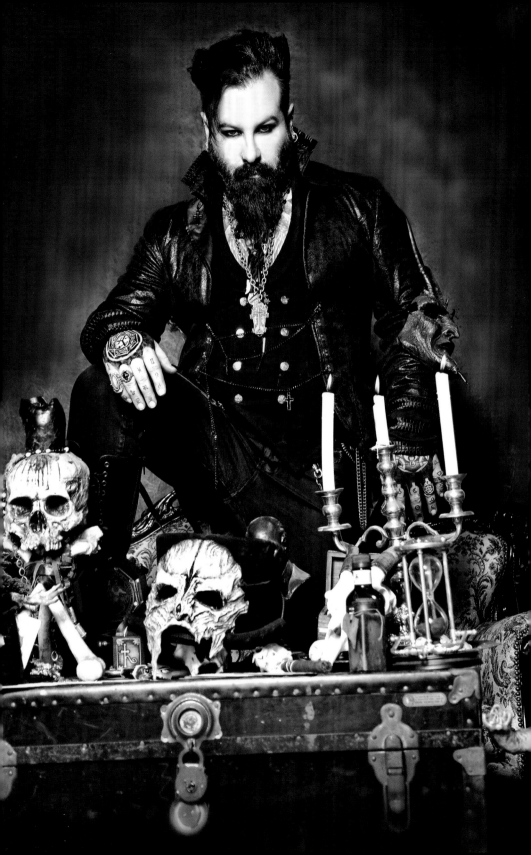

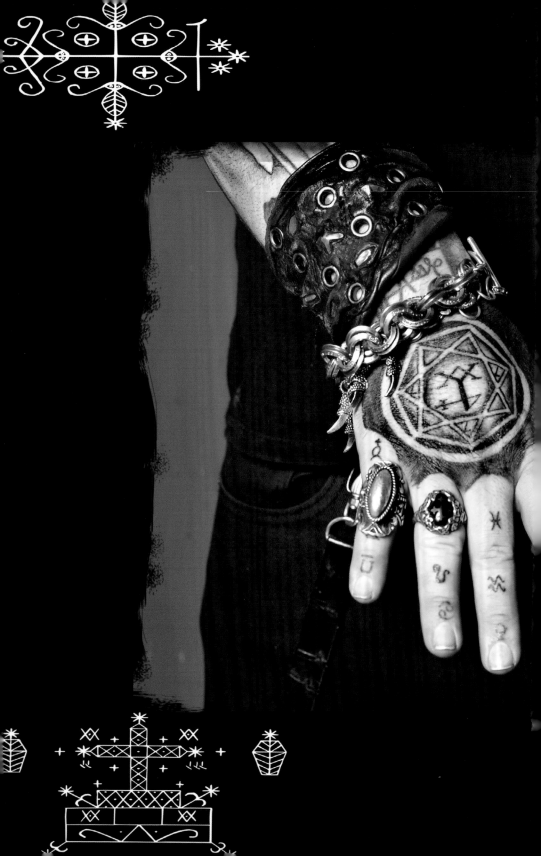

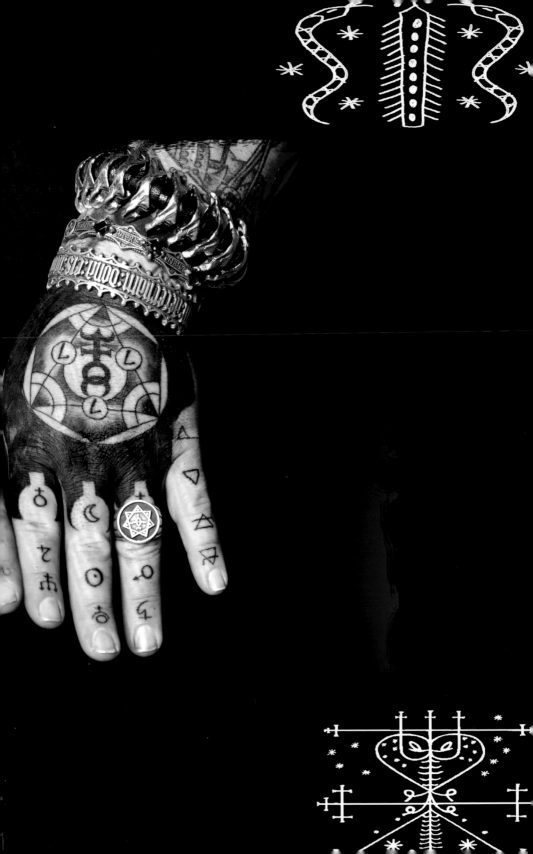

ANIMAL SACRIFICE

What about blood sacrifice and Voodoo?

Hollywood overemphasizes the blood in "blood sacrifice" instead of the sacred aspect of *sacrifice*. Libations, herbs and tobacco, dancing, drumming, singing, cooking, and so much more are all worthy sacrifices.

In some strands of Voodoo, especially in Africa, Haiti, Cuba, and Brazil, there is blood sacrifice. When the usual chicken, pig, sheep, goat, bull, or other animal is ritually sacrificed he is treated well, danced with, and offered ritually. Generally the animal is cooked and shared by all the participants, but is first and foremost offered to the spirits (Loas).

In cases such as healing deadly diseases, heavy justice, or occasional dark intent where poisons are expected to be mystically transferred into the sacrifice, the animals are not to be eaten.

It is of course not just Voodoo that is blasphemed for blood sacrifice. Every religion has had its day of blood offerings; after all, "The blood is the life."

Many of us regularly partake in a more mild-mannered version of a ritual sacrifice when we hire our hitman at the corner butcher.

In this photo you see the butcher in his apron reminiscent of this accepted modern version of blood sacrifice. As he holds the pig head he mixes the old with the new, and scenes of revolution could dance through your head. In Haiti it was a pig that was sacrificed to the Kongo Petwo spirits to kick-start the Haitian revolution, and to give strength and victory to this slave rebellion. To this day the pig is a favored offering for many of the Petro (Petwo) Loas. They are the more aggressive and the fiery class of Haitian Voodoo Loas, evolving from a combo of Kongo nation spirits, local native spirits, and heroes. The revolutionary victory was considered a Voodoo miracle and resulted in Haiti becoming an independent and slave-free nation. This little piggie helped tremendously, and its power led the army to march on to victory!

> Many of us regularly partake in a more mild-mannered version of a ritual sacrifice when we hire our hitman at the corner butcher.

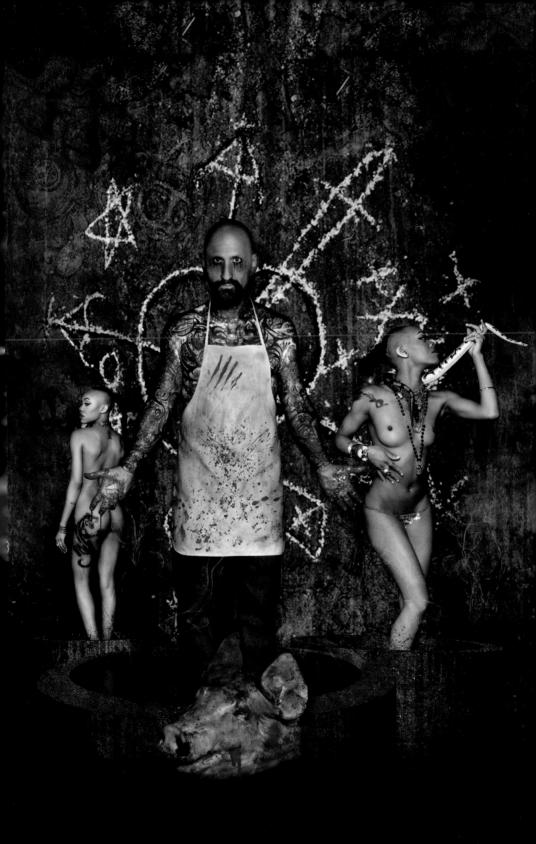

CURSED HEART

Love can create and destroy and it indeed does both. As a veteran Voodoo priestess I've seen it all and heard it all: requests to break a love curse thrown; calls to send a curse; pleas to break up a couple to get back a "one and only"; calls from those who seek revenge; or worse, requests from those who want to force a love that isn't real. This is all really about control, and not love.

Can your partner leave you because a curse was thrown? Yes. Are Voodoo love curses usually the reason why people break up? No.

Be vigilant in your relationship, spice it up, cool it down. Keep it strong and cleanse it well. (If only people would call before the damage is complete and look at Voodoo as more of a maintenance program instead of an emergency room.)

I make Voodoo tools to help a love life. These spirit tools can enhance the mood, pull love toward you for attraction, but you have to develop it after that. Love is fickle and you need to work with it and nurture it.

Love curses are the most commonly feared. Most people are really not the victims of a curse. Hollywood and the internet interlopers selling breakup spells under the guise of Voodoo are plentiful, all making Voodoo look shallow indeed.

Now, can a love and cursed heart exist? Of course, yes. Can we overcome? Yes. Is it a renegade or jealous ex-lover tainting the heart? Perhaps. Is it just our guilt and lack of self-assuredness? Maybe. Can you release the sadness and scorn from your own heart to set it free? Yes, but it will take work. These are questions that need to be asked.

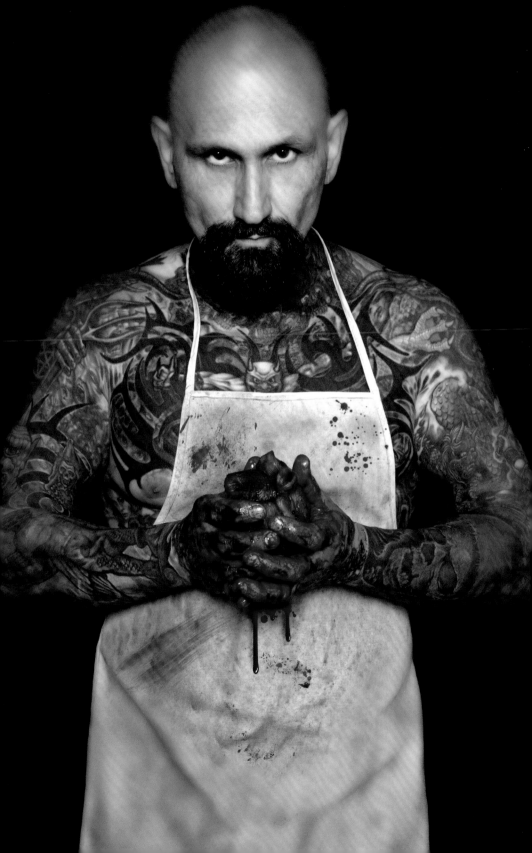

THE ERZULIS

Erzulie Freda is the Mysterie of Love. She is the Voodoo Venus. She is the sweet frilly flirty girly-girl and all that is fair and of beauty. She has three husbands, countless human lovers, and is seductress extraordinaire. She indulges in luxury; she is perfect (all that love should be). But yet she cries and cries when she comes to mount her horse (possess the practitioner). For in love is also regret and loss. She carries a dagger in her heart. For she is Love and the pain of love. Love hurts so she cries.

Feed her pink champagne, chocolates, jewels, and beautiful things.

She has a fiery sister known as Erzulie Dantor. She is a strong protective mother who carries her child. She is a spy and soldier too. She shows as the black Madonna, or here in New Orleans as Our Lady of Prompt Succor, the Virgin Mary with Child. She carries her daggers and sword outwardly.

Our Maman, You are seen in the deep as the mermaids, as another side, a deeper side of Erzulie—Le Sirene.

The mother Mami Wata is *the* African Water Goddess but there are many Sacred Keepers of the seas: The Santeria sister is Yemiya and her sister sweet water Orisha extraordinaire Oshun, then I bow as I add my "Maman You" here in New Orleans Voodoo, plus the ever popular Le Sirene, Haitian Voodoo Loa star who swims with two husbands: the great Agwe, a Voodoo Poseidon of sorts and the hybrid alter ego and mate in La Baleine, the whale of fortune and smooth travel . . . (from *Bloody Mary's Guide to Hauntings, Horrors, and Dancing with the Dead*)

Le Sirene and company are not mere women or myths, instead they are intricate spirits ruling a woman's rhythms, guiding us from the depths of the waters with primordial song and innate wisdom.

> She carries a dagger in her heart and she cries Who am I?
> The true expert on love is—Erzulie.

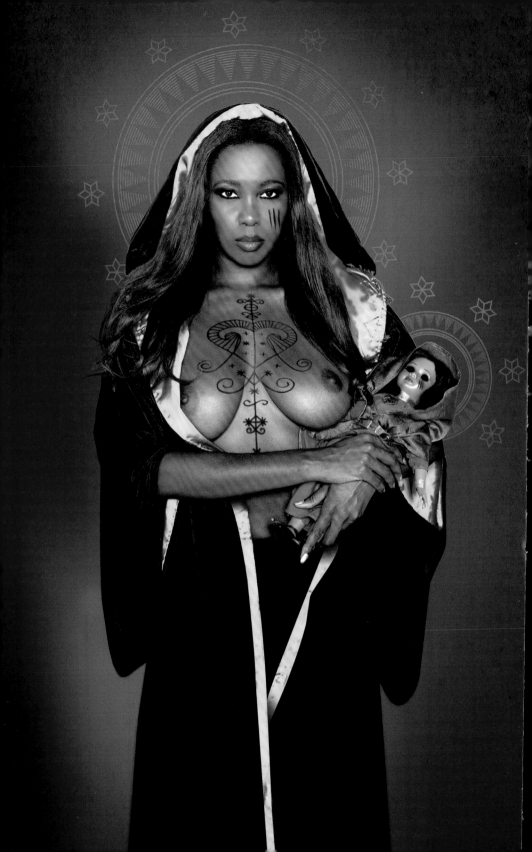

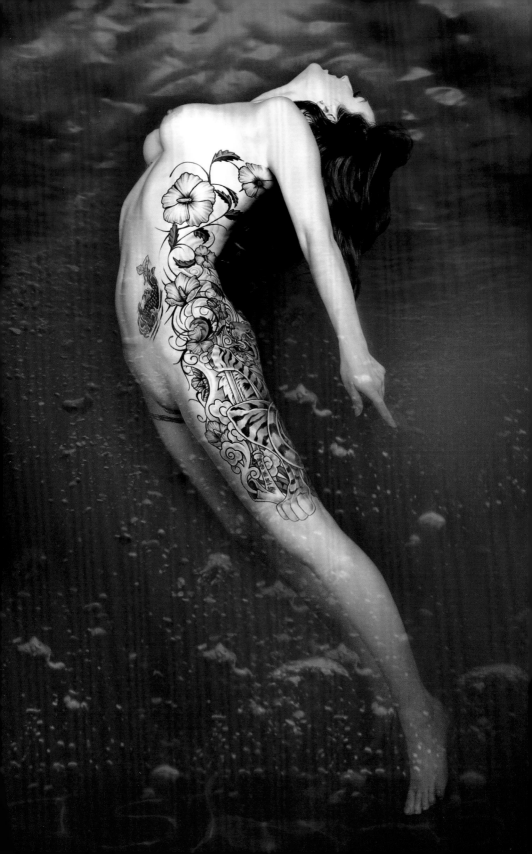

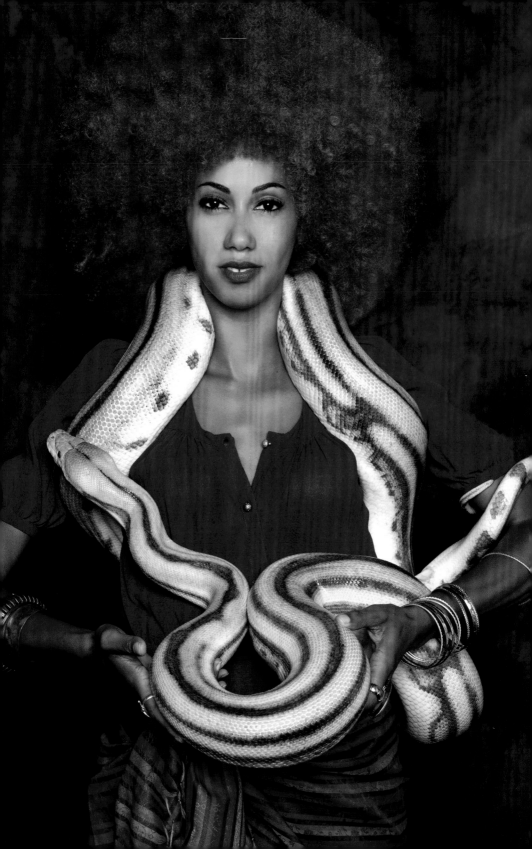

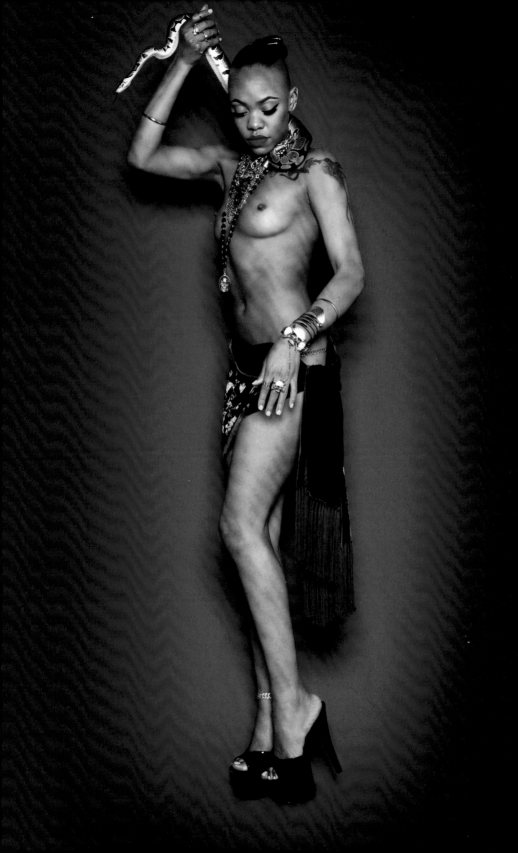

SNAKES

E very generation paints Voodoo and Marie Laveau in a different light, or dark. Yet the image of the snake, the image of the swamp, and the image of female empowerment intertwined with the snake are part of each and every one.

Our lovely swamp lady, our Voodoo model and her partner, the snake, sport Voodoo tribal war paint and dance nude by choice. But critics of the past painted Voodoo ladies, against their will, as lustful ladies of the night. The snake is a powerful symbol in Voodoo and though it certainly has a sexual connotation, for Voodoo it is regarded more as a symbol of death and rebirth, healing, and first and foremost, mysticism. Snakes dominate Voodoo, from the patron snake spirits in New Orleans Voodoo, La Grande Zombi, and Maman You, our cryptid woman atop and snake lower-bodied water mama, to root spirit Blanc Dani, even including cousins such as Simbi and topped off with the pièce de resistance, the all-encompassing serpent and the rainbow: Damballa and Ayida Wedo.

This particular power snake couple are shared in almost all the Voodoo cultures from Africa to Haiti, and in New Orleans we still honor this sacred duet as life source mysteries. Here in my hometown Voodoo culture, the retention of the dance of the snake still reigns queen as it should. At the mouth of the Mississippi, the largest snake in our nation, we New Orleans Voodooienes still dance with actual snakes. Just as with the ancient African serpent worship in Whydah or even a more classic comparison of the oracle of Delphi, the snake is a conduit of knowledge, wisdom, and oh so much more.

Fantasy-fueled fears of Voodoo complete with snakes, love curses, and zombies fill the silver screen. Marie has been plied as a devout Catholic, folk saint, healer, all the way to a femme fatale, and love-cursing, power-hungry she-devil immortal that Bobby Bare made a household name in 1974 with his top ten hit "Marie Laveau."

The reality was probably much more of a confluence. But we do know she was not a murderer as they portrayed her in *American Horror Story*, and not an eavesdropping hairdresser using secrets stolen from her clients to blackmail her way to the top as books like *Voodoo in New Orleans* by Robert Tallant suggest, nor was she an activist for slave rights like Harriet Tubman, as many modern historians try to paint her. The woman Laveau was instead a perfect product of her environment and a nineteenth-century local New Orleans strong free woman of color: mother, wife, lover, healer, and the quintessential Voodoo Queen.

> The snake is a powerful symbol in Voodoo . . . regarded as
> a symbol of death and rebirth, healing, and first
> and foremost, mysticism.

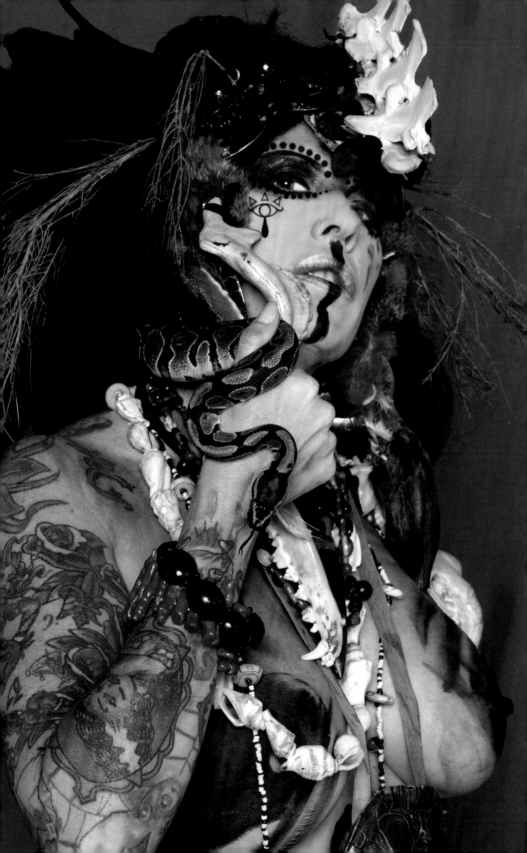

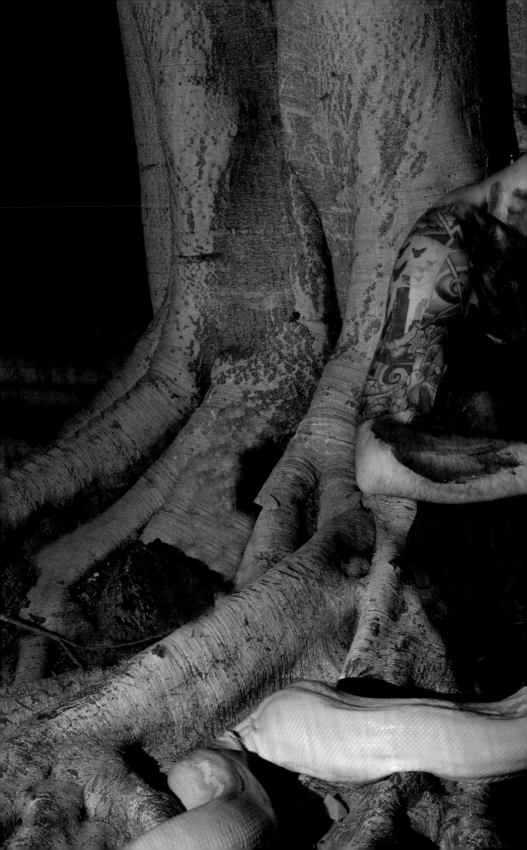

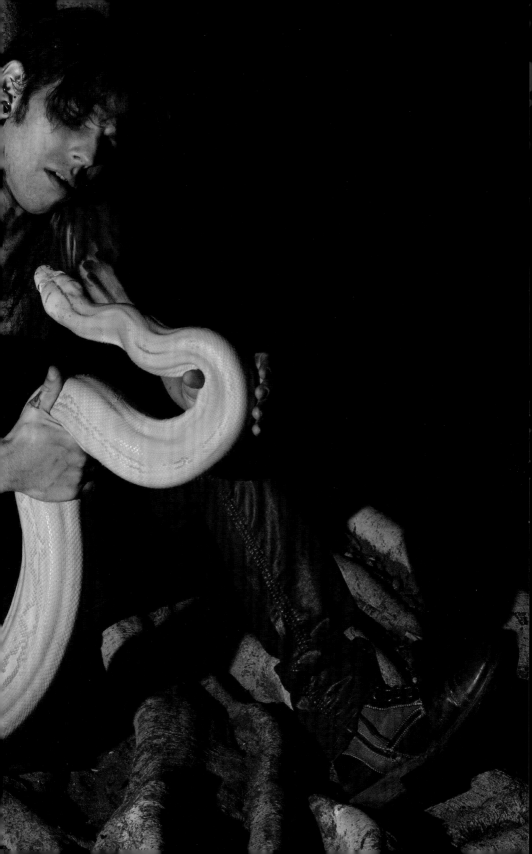

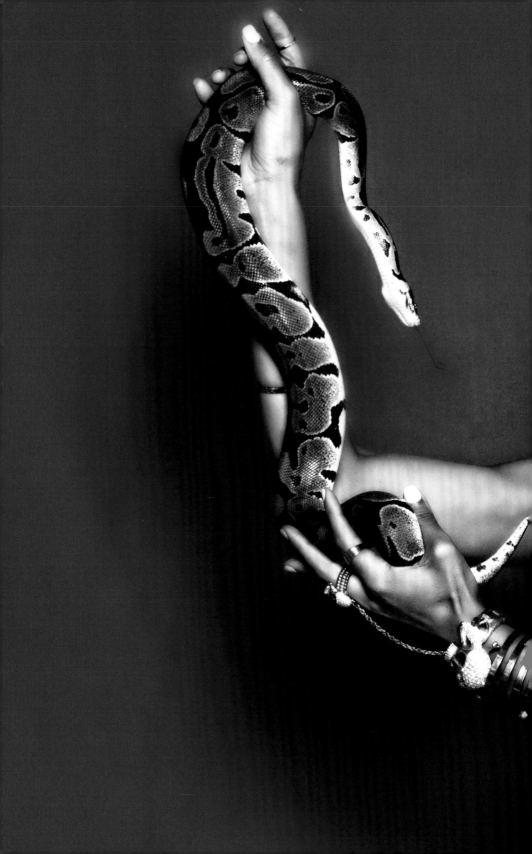

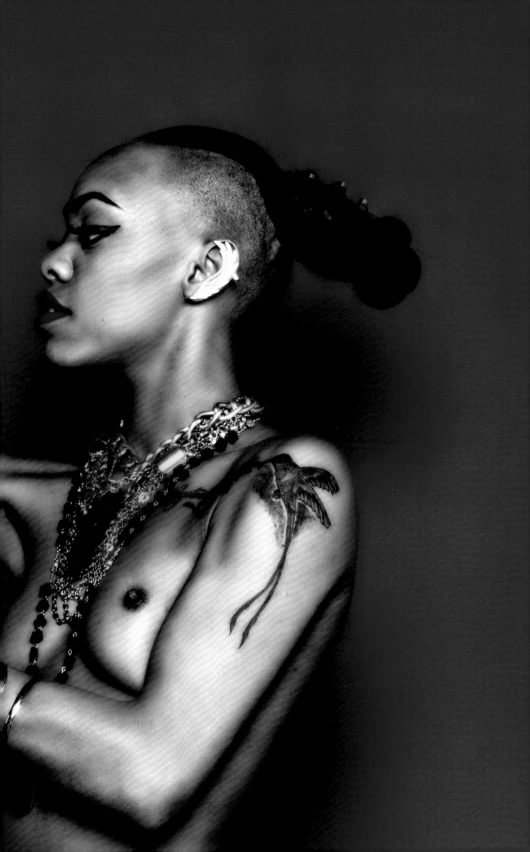

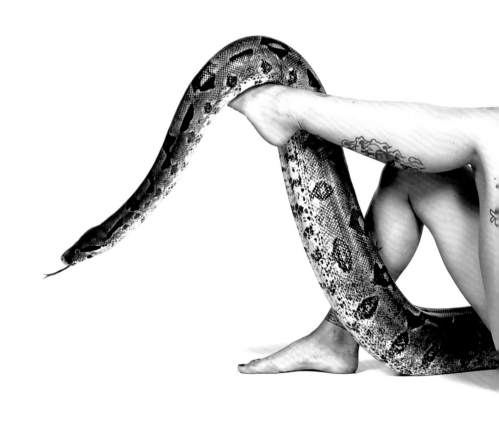

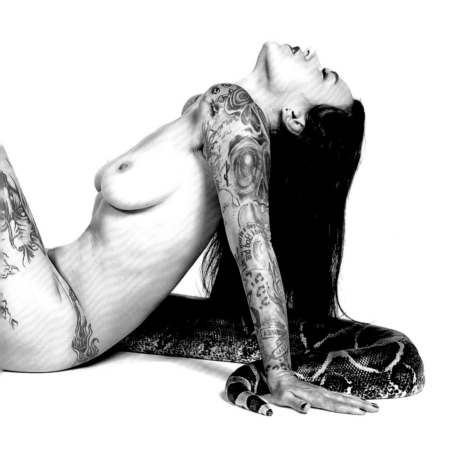

DAMBALLAH & AYIDA WEDO

Damballa is a sky god and creator spirit. His color is pure white. His wife is Ayida Wedo and her color is also pure white. His lover is Erzulie Freda. Damballah is associated with St. Patrick and sometimes with Moses.

Ayida Wedo is a sensual Loa of fertility, water, and snakes. She is the snake that creates rainbows. She is a pure, sacred, and revered root Loa. Ayida Wedo is associated with the Mother Mary in Catholicism, but I like to think of her as associated with the Oracle of Delphi.

It is when these Loas are together as a couple that their mystery and power is realized. They are the Serpent and the Rainbow actualized when wrapped around the cosmic egg of creation that holds the world in place.

In service to the Serpent and the Rainbow, plates of white flour are offered with a fresh, white egg, animal offerings of chicken, white foods, and cakes. The couple also receives offerings of alcohol. They love an almond syrup known as oregat. There is always a white sheet waiting, should a Damballah or Ayida Wedo possession occur in ritual. Ritual possession is a safeguarded goal in Voodoo, used to communicate with the Loas directly and for them to feel the human side through you.

When in a trance state the servitor may be taken by spirit and for that time the person is the Loa. During possession by the Serpent and/or the Rainbow, you need to cover the person possessed with a white sheet. This Horse (the one who is ridden by the Loa) is usually writhing on their belly like a snake, still covered with the white sheet. They will tend to plunge into a basin or pool of water, which should also be nearby. They may eat the offering egg without the use of their hands and drink the sweet almond nectar.

Other types of psychic and supernatural feats can occur when the Loa appears. The Horse can speak, heal, prophesize, and do many superhuman things.

> They are the Serpent and the Rainbow actualized when wrapped around the cosmic egg of creation that holds the world in place . . . Plates of white flour are offered with a fresh, white egg, animal offerings of chicken, white foods, and cakes.

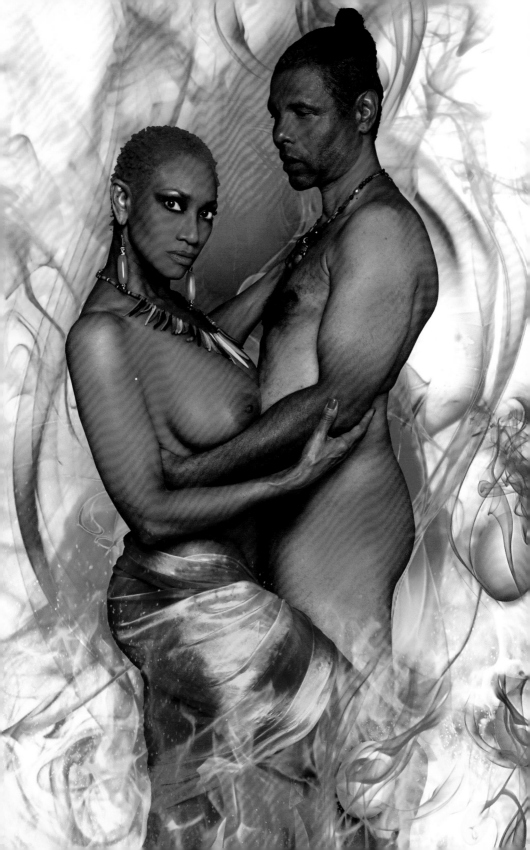

MARIE LAVEAU

'm an eleventh-generation Creole New Orleanian. We've all known since childhood that the tomb of Voodoo Queen Marie Laveau was the place to ask for help, to make a wish, and to confide private things that should not be told. We knew to mark our visit with a brick-chalk crossroad X, as well as to bring pennies and gifts so that she would help. This is something I have known my whole life!

Hardcover books have recorded this practice since as early as the 1920s and everyone's grandma passed down these traditions since even earlier than that. I teach the New Orleans Voodoo Marie Laveau traditions to this day and escort visitors to her tomb. But still we need to ask, who was Marie Laveau?

Would the exotic nature and devil-may-care attitude of New Orleans Voodoo Queen Marie Laveau be as compelling if she hadn't danced naked with a snake at the lake on St. John's Eve? It probably would not, but she probably also did not.

If Marie Laveau ever went "sky-clad" at her private rituals or while she concocted her gris-gris and stuffed her rag dolls, no one living really knows but it is highly doubtful. But we do know that "they danced naked in their little chemises." This overused quote by onlookers about descriptions of Congo Square rituals is oft repeated, but one wonders . . .were they naked or in little chemises?

And what about the drunken orgies that they say took place? She say, hearsay— no way! These orgies were more Bacchanalian than Caligulian, in older definitions anyway. And I do not think that the drinking part is anything new in New Orleans.

Marie Laveau had two husbands and many children. They say she had a lot of lovers, too. So she did have her power and some sex appeal as she was certainly a well-rounded woman.

She died at home in her bed, on the hottest day of the year in the house on St. Anne Street where she was born; the house that she got from her grandma. Her demise was not as glitzy as dying in a storm in the lake like they say, but a humble death followed by a well attended church funeral. The *New York Times* even printed her obituary.

Photographer Justice Howard's Marie Laveau is literally stripped so she truly has nothing to hide. She is totally exposed, strong, free, and beautiful. To pull the real Marie Laveau out of the pages of time is an arduous task whether she be sky-clad, loincloth-covered with seashell brassieres, or in a plain blue calico dress with lace-up shoes as was described by those who knew her.

Marie Laveau's spirit sightings are reported at her tomb shrine and all around town. People still come to Marie's hometown in search of her. They come to New Orleans to tap the root, and take the power that our mother river so freely pours. But you better stay on the river's good side. Marie did. Many do. I do. Marie holds the candle that leads the way for all those seeking magic as they flock here to New Orleans. Salute her or she may burn you with the same.

So who was Marie Laveau?

Mamma, mambo, mamaloi, spiritual mother, Voodoo Queen, witch-doctor, traiteur, devout Catholic, priestess, wife or lover, witch or nurse, black or white, sinner or saint? Yes.

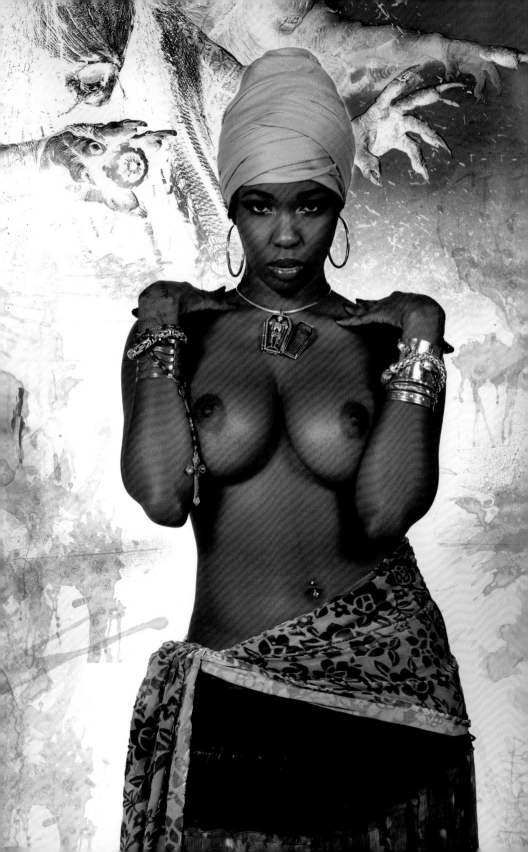

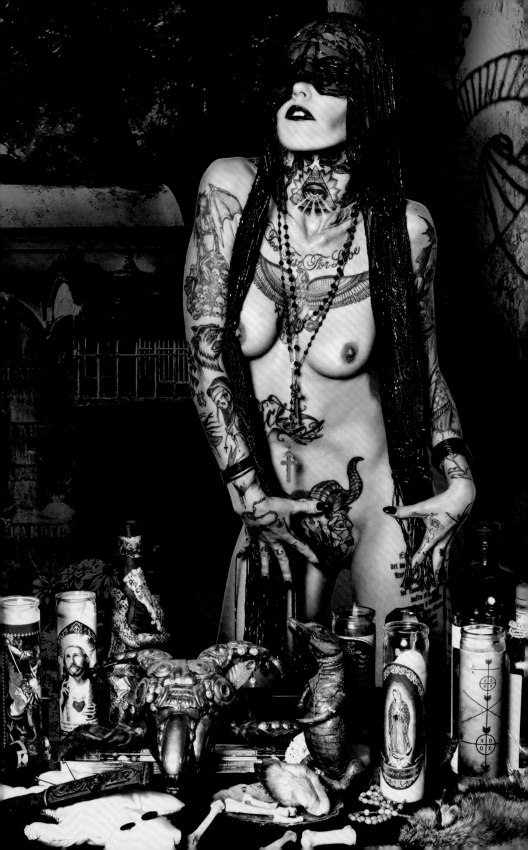

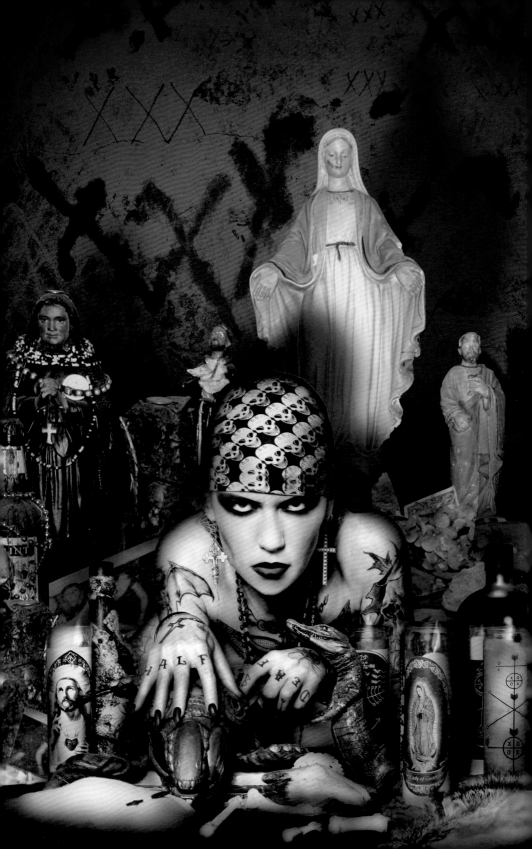

VOODOO DOLLS

Voodoo dolls: Effigies representing a person or spirit; a focusing device; a house . . .or a vessel . . .

In other words: Voodoo dolls are surrogates who can be horse-hair rag dolls filled with Spanish moss, wool, cotton, corn, beans, herbs, and more. Spanish moss, known as horsehair, is very important to the New Orleans local swamp magic.

The body of a New Orleans Voodoo doll is generally a cross made with sticks from your favorite or most empowered tree. It is then wrapped with long strands of moss that have been imbued with prayer. However, the physical act of making the doll is only one part of the process. You must imbue it with life through its umbilical cord with your breath and special words of power. You need to awaken it and sustain it. Each knot is a binding, tying intentions and desires. Each button, sequin, pin, or thorn represents a mystery. Use these symbols as power points to direct, focus, release, and bind. Everything you add to your doll has symbolic meaning: hair, old scraps of clothing, or even nails of the person whom it represents furthers the connection.

Warning: This is *sympathetic* magic, not simplistic! There is a living spirit within many Voodoo dolls, and some versions are tricky. If you use those pins at all it is to further pinpoint, release, contain, or transform the power. It is not a direct and oversimplified process of "cross your heart, hope to die, stick a needle in your eye."

You can make a doll or buy one, but if it is not directed, talked to, fed, or offered payment of some sort it will not work.

Voodoo dolls do not have to represent a particular person; they can be a home for a spirit guide, Loa, or ancestor. Some effigies are also known by terms like niksi, mannequins, or poppets, and exist in cultures and religions around the world. Though Africans may have been more fond of carving wooden effigies in their homeland they were no strangers to mystic trade with mainland Europe, or to Middle Eastern magic. They already had some stuffed sand-and-herb-filled doll versions in Africa (some larger than life size) to house the ancestors, so it is impossible to say where this practice developed

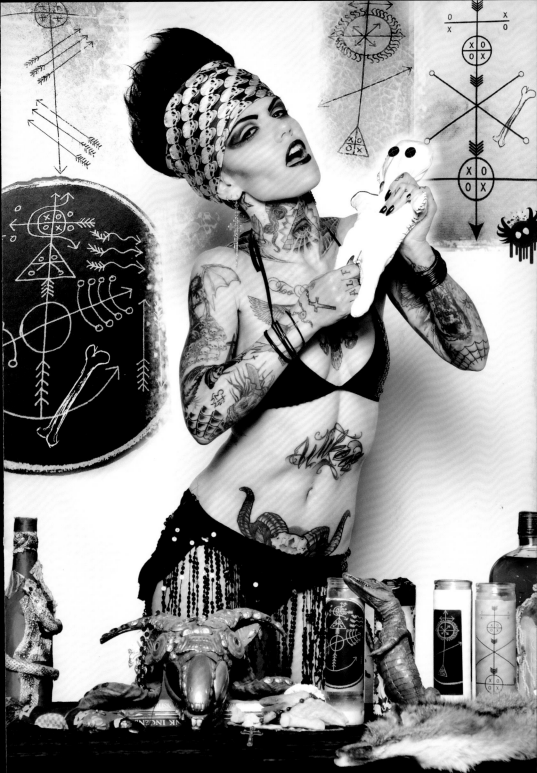

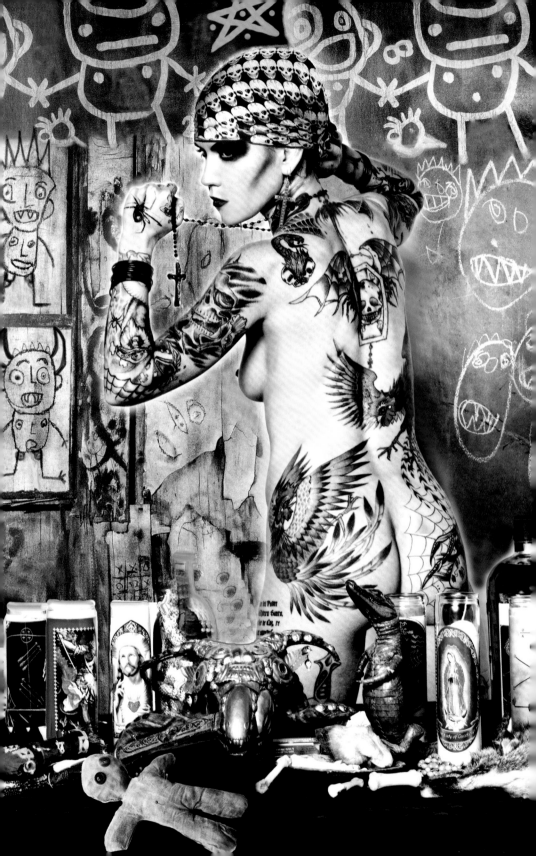

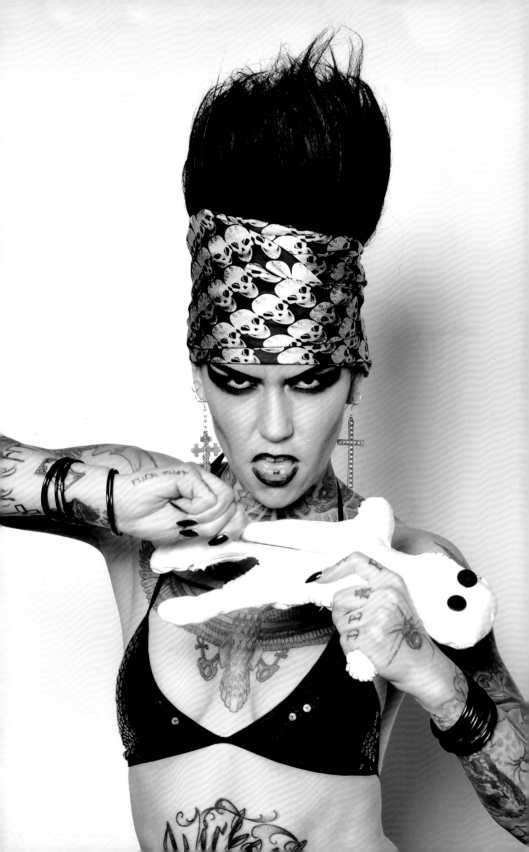

first. All of this and more travelled beyond Africa with the Voodoo diaspora.

Along the journey many styles freely mingled with the European poppets, religious waxen figures, and Native American cornhusk, moss filled, or Kachina style effigies. The dolls all danced together and became one known as Voodoo dolls. This was especially true in multicultural and oddly permissive New Orleans Creole culture, where these "fetishes" were available out in the open at markets and were just a knock on the door away, in the middle of the night, at the home of your local Voodoo Queen or Hoodoo Doctor.

The Voodoo dolls then and now are but innocent tools, which can be used for harm or good; it is the intention of the user that dictates the outcome.

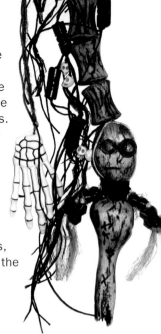

THE WHITE LIE

I do not teach dark usage of Voodoo dolls. I have made more than one hundred thousand healing helpful spirit allies over the years, for moms, dads, students, scouts, sects, covens, clubs, and corporations, too. I've taught how to and what not to do in classes, in direct rituals, and at conventions for decades for clients of all types. I have America's only Voodoo doll-making bar and gris-gris apothecary in my Voodoo pharmacy in the French Quarter.

In special classes and workshops I coach and consult as I guide both regular and irregular everyday people and high priests of other faiths on how to make their dolls. I create them to help empower people on their road to self individuation. They can be your helpers.

I am not naïve or foolish enough to try to whitewash the whole Voodoo doll practice and try to convince you that all dolls are for good, for this is a lie. It is true that some stick pins in Voodoo dolls to make the person bleed, metaphorically and otherwise. However, this is not the religion's teaching; it is the way of man. Some contemporaries of mine claim that dolls only came here to the US in the early twentieth century and became an overlay to Voodoo, but the religion's practitioners would never claim such a thing. Many people simply do not do their research, others may not be from here, or they just have an agenda to whitewash and rewrite history. I ask you, who does that really serve? Certainly not the poor little Voodoo doll who gets thrown this way and that in the process! One need not be embarrassed about the past of our multicultural shared magics. If anything, let all the realities come to light so we can clean out the closets and gain from their wisdom and learn from any of their past mistakes.

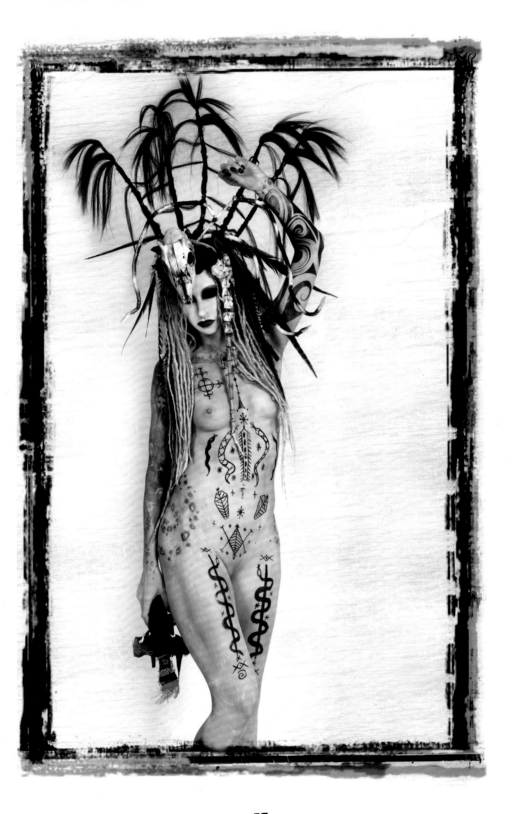

It is true that many people do more dark magic when times are tough. Wars, recessions, reconstruction, and generally just whenever humans disconnect and lose faith. Human nature has the unfortunate habit of trying to destroy others in order to get ahead. Dolls are the true Voodoo scapegoat.

Unfortunately the downtrodden spend more time trying to undo others than trying to connect with the source to find their own ladder to success. It is human nature itself that needs to realign and correct its stance. The doll is just an innocent bystander and not at fault. Voodoo dolls have definitely taken a bad wrap—pun intended!

Warning: Many Voodoo dolls in New Orleans and trickling across the nation are made in China. (One of the Voodoo dolls in this book is made in China. Guess which one? It's not the one in Justice's hands here!) Nowadays China is no stranger to making Voodoo dolls, constructed of materials like paper, grass, hay, rice, and maybe even formaldehyde. When you buy Voodoo dolls, you really should buy local!

See *Paranormal Blue Book* in the bibliography.

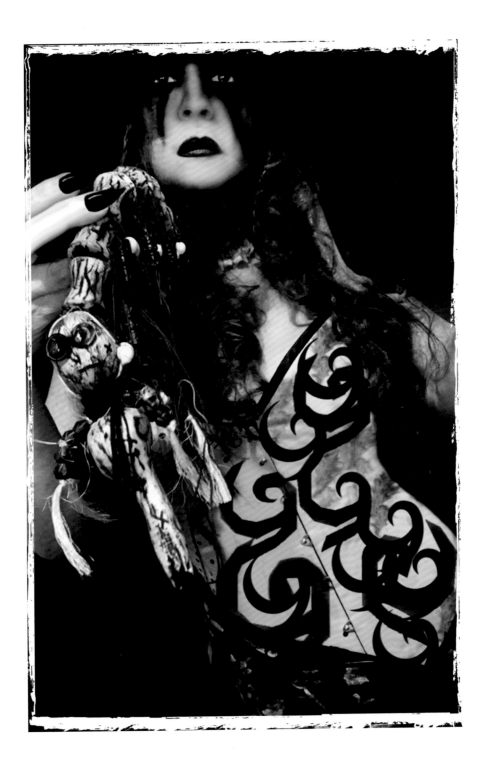

HAND OF GLORY

Both before and after the slave trade Voodoo was no stranger to the influence of the European historic old religions including the stirrings of witchcraft. Voodoo is mostly thought to be the first and oldest of religions so it is seen to welcome new knowledge and trade mysticism, as it still does today. Yet it truly 'tis more witchcraft that claims this Hand of Glory spell.

The left hand of a dead hanged man at the gibbet or something as equally difficult to obtain was an occult prized possession. Of course no one trains students to go get such things or to grave rob in this modern day, but the items still exist from days of old. There are occult collectors, antique spells, and working relics that pop up to lend a hand.

A popular European grimoire spell book, a treasure beyond treasure, was the *Petit Albert*. This eighteenth-century magic book was truly treasured by nineteenth-century New Orleans Voodoos. They say Marie Laveau herself had one! This book gave many spells including details on how to acquire the hand of glory and how to shake and bake it too!

But no worries, seeketh thou own treasure still with just the spirits at your side if no hand comes your way! To many practitioners, a simple five-finger candle and secret words of power act as a stand-in for this historic piece of "double double toil and trouble, fire burn and cauldron bubble"

But others believe dead men have no part in this scenario. Mere translations have confused the meaning of the words "hand of glory" with French words for the magical powerful mandrake root (mandegore), "*le main de Glorie.*" The greatest of European roots is the mandrake. I own the root, not the hand, but the relic pictured here is real. So is the Hand of Glory really necromantic or is it herbal magic?

A popular European grimoire spell book, a treasure beyond treasure, was the *Petit Albert*. This eighteenth-century magic book was truly treasured by nineteenth-century New Orleans Voodoos. They say Marie Laveau herself had one.

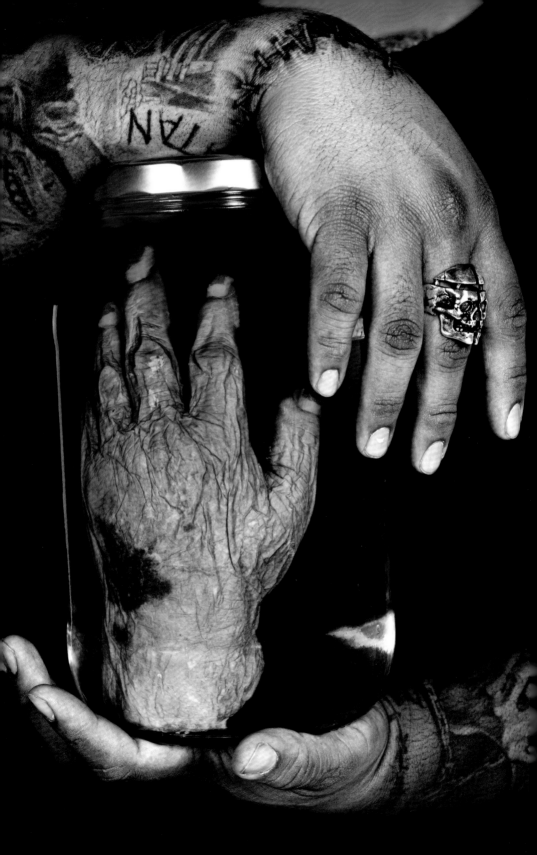

VOODOO QUEEN

New Orleans Voodoo traditions have their mystic Voodoo Queens, as did Africa. In New Orleans they held many roles: mambos, mamalois, mothers, mediums, teachers, and traiteurs. They are tasked as keepers of the old traditions and are priestess mothers to spirits here.

Even during the nineteenth-century Voodoo days of *the* quintessential Voodoo Queen Marie Laveau, there were white Voodoo Queens and practitioners. Because women are women, they shared some of the same plights and joys, so their powers joined forces to lift and overcome. Our people blended, our customs blended—and the Queens, they blended too.

Everything together in this savory brew known as New Orleans Voodoo is held in place with a swamp magic base. Justice Howard has her artsy maiden emerging from the mystery of the finger lakes (also known as bayous!).

The local Native American spirits met the African Voodoo spirits, who came straight from their homeland with the slave trade. They blended not only with one another, but also with the Saints and ritual beliefs of the Latin Catholic society. These herbal healers and spirit walkers were hard-working women from all strata of society. There were also some men—the Doctors and a few Kings—but it is the Voodoo Queens who hold it together.

All the countless and faceless Voodoo Queens still exist and work right alongside those more famous ones. There is a whole line of queens that stretch back to Africa . . . a line still moving forward. You are passed the title of Queen and there are apprenticeship years. The Queens sent that dream vision of initiation my way over a decade ago. It was formally passed to me from the Voodoo Queen Margaret and she got it from Queen Rose before.

But when you are the Queen you are the Queens. We are blended.

Even during the nineteenth-century Voodoo days of the quintessential Voodoo Queen Marie Laveau, there were white Voodoo Queens and practitioners. Because women are women, they shared some of the same plights and joys, so their powers joined forces to lift and overcome.

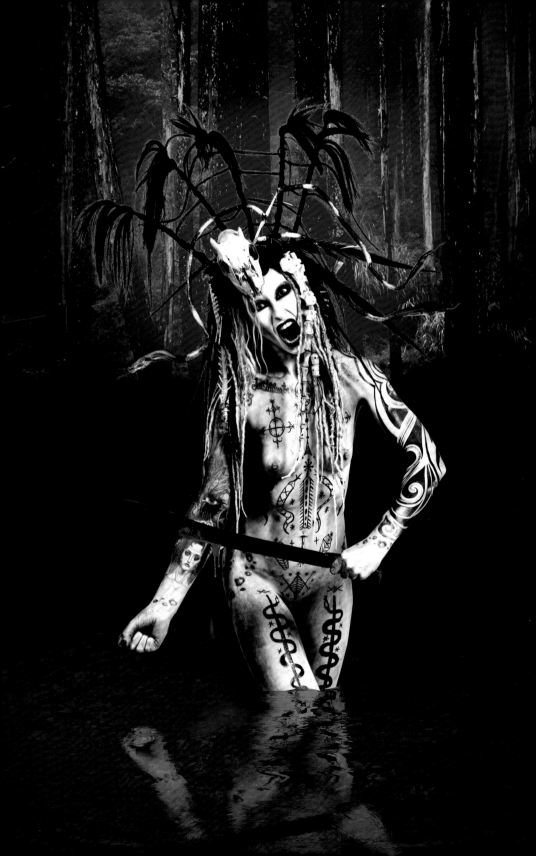

OGOUN

The Blacksmith, the Warrior, the Diplomat.

The transformative power of Ogoun is in your pocket; call on his fire at your heels when you need to move forward with might and power. The wind in your hair and the smell of burning rum helps wield Ogoun's machete when he clears the path. Ogoun or Gu is the controlled burn and the forge itself. The clearing of the swamps to build the city of New Orleans had the hand of Gu in on the reap, then as the city grew, his iron balcony braces supporting her town houses were blessed by his name.

With all the iron in New Orleans, Ogoun's fire stands as a powerful partner to our mother Maman You, the river maiden. Some of New Orleans iron was wrought by local slaves and indeed has the song of this Master Smith Saint Gu in its lacy bend. He rides firm, drinks hard, tests and shapes you in his flame. We just call Ogoun Feray "Joe" in New Orleans Voodoo, a more familiar call: Help us Joe! In Africa, Cuba, Brazil, and New Orleans you will find many Ogouns. Some family traits and regional differences can be noted in his many brothers.

Our Voodoo Grandfather, Papa Edgar, gave us Ogoun Ashade. When possessed I recall Papa Edgar just couldn't get enough rum to pour for Ashade; he certainly loved his rum and his flame! I remember Edgar striking a match to light a cigar and Ashade immediately stepping in and applied the lit tip of that fat cigar to the bottom of my eleven-year-old son's foot! Then in the blink of an eye he turned and doused my son in a quart of rum immediately transforming him into the perfect image of a helpless shaggy puppy returning defeated from a tumultuous New Orleans thunderstorm. He stood stunned as he absorbed the unexpected events and puddled the temple floor from his rum soaked ritual whites. This was an early blessing possibly providing the fortitude to fight through the Katrina battle close at our door; that momentary defeat became a source of strength when the real storm came knocking. Thank you Ogoun. (You must realize that my son did not get burned or harmed in anyway; we both knew Ogoun would not let that happen and had faith.) Ogoun is a brave spirit and can transfer that to you. Ogoun's battles come in many forms, as do his possessions.

Trance dance possession is the most well-known way that one connects with Voodoo spirits or Loas and learns by becoming. Here the practitioner or Priestess becomes the medium or channel and is referred to as "the horse" when the spirit

> Ogoun's battles come in many forms, as do his possessions.
> Trance dance possession is the most well-known
> way that one connects with Voodoo spirits or Loas and
> learns by becoming.

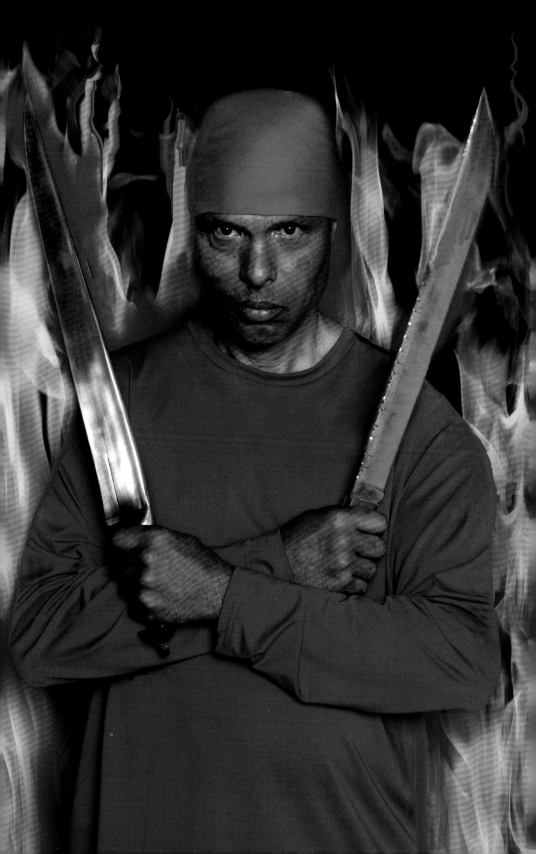

mounts her. Of course, there are also other ways to connect than to bow to spirit in dance by the beat of the drum in this manner. There is also dream possession communication! Some say "never wake a mambo!" Why? In my case I know I can be in the middle of some incredibly delicate astral workings during sleep time. There is a lot of healing, negotiating, learning, traveling, and battling in the astral planes with the Loas directly. The protection and guidance of Ogoun provides invaluable insight and impeccable strength on these journeys.

In general Ogoun is most associated with St. James Major but some also match him with Joan of Arc, the Maid of Orleans. I have also been privy to other secret alliances and graced info for my personal arsenal from this noble warrior. The Spirits still speak to you in Voodoo. Ogoun works in many ways and his emanations are multifold. Hail Ogoun!

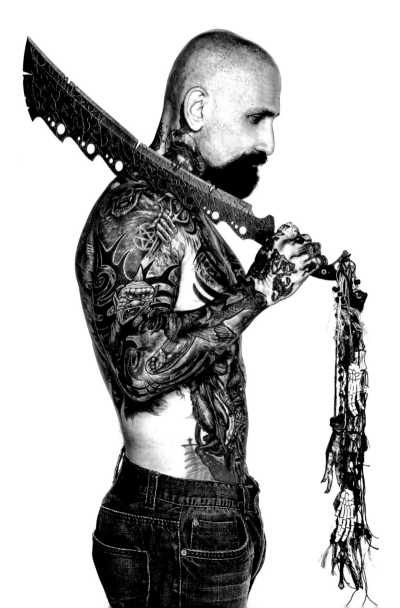

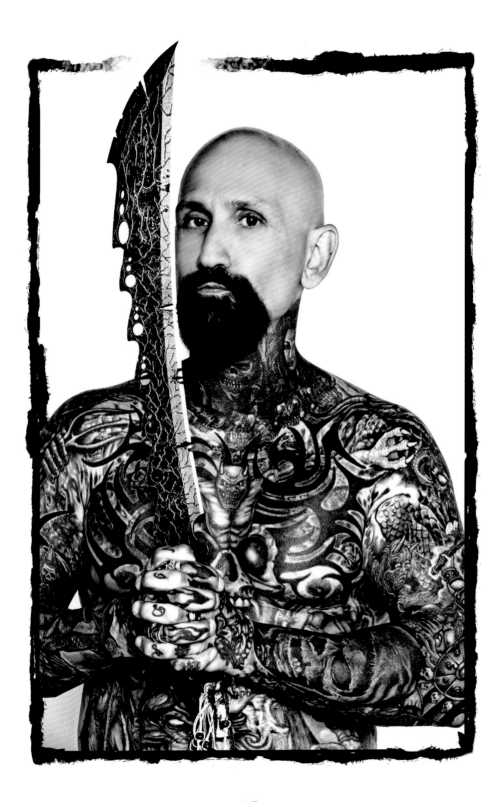

RATTLE DEM BONES

There are many types of Voodoo but hey, all stem from Mother Ancestor Africa. The tribes and the spirits traveling alongside them settled where the slave trade took them and evolved according to the needs of the people there. Santeria is an Orisha-based religion and cousin to Haitian and New Orleans Voodoo. This kissing cousin is predominantly a Cuban African diasporic religion influenced mainly by the African Yoruba tribe. The United States had many mid-twentieth-century Santeria practitioners that moved here, fleeing from Cuba with their own traditions which now flourish all over the country.

Bones are not in Voodoo altars to instill fear or to represent darkness. Bones represent the commonality of death to all man and also solidify life remembered. They tell a story.

The use of bones in meditative or conductive ways is most commonly found in cultures that practice a long tradition of ancestral reverence and have a special place in their heart for bones. The possession and reverence of human bones is certainly not limited to Voodoo. It is still part of the mourning process to remove the bones of your loved ones, clean them, and reassemble them on November first as an extended part of the mourning process in some Latin Catholic countries even today. Toussaint or All Saints Day in French Catholic areas still recognizee November first and November second Day-of-the-Dead-type celebrations as Holy days. Voodoo celebrates its own Fete Ghede (Festival of the Ghede Mysteries of the Dead). Bones are all over the Vatican and decorate European Catholic churches, catacombs, and sacristies. Owning precious relics of the Saints helps you facilitate miracles though the intercessory power of just a mere chip of their bone or cloth that wrapped the remains. This idea of healing relics stems from many ancient religions like Voodoo, Native American shamanism, and old European classical and heathen beliefs. And by the way, the world, the very earth we walk, is also made of bones of those that came before.

Mambos and mediums may also use bones for psychic communication with the dead. Bones can be vessels to house a spirit, enabling spirits to manifest more easily for clearer communication. But bones are also used by magicians, artists, actors in theatres, interior decorators, and so on.

> Bones are not in Voodoo altars to instill fear or to represent darkness. Bones represent the commonality of death to all man and also solidify life remembered. They tell a story.

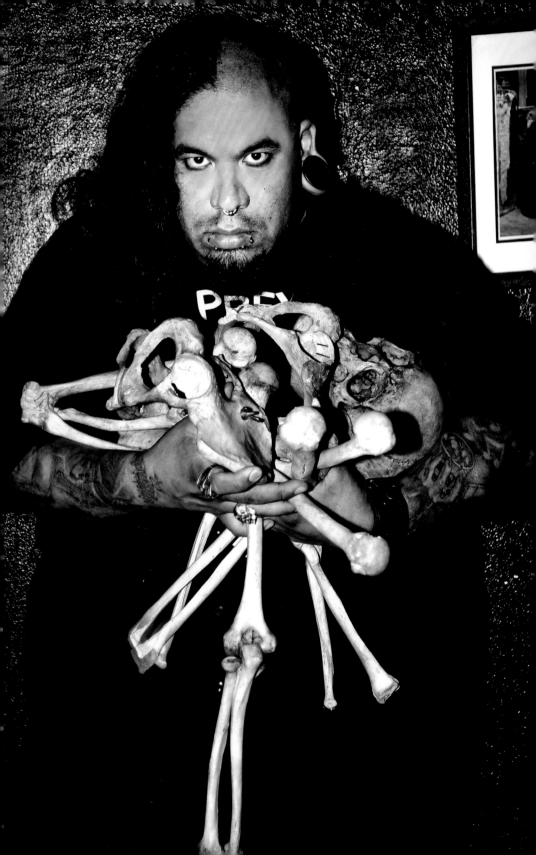

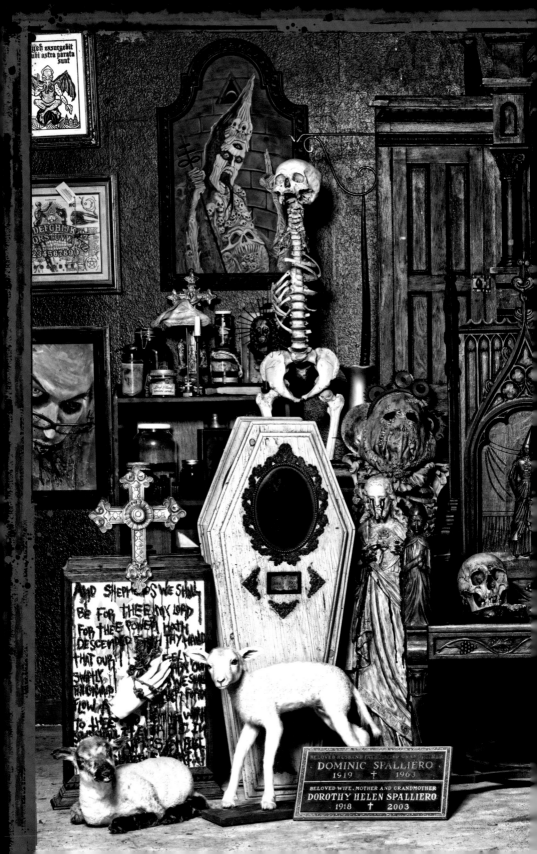

BELOVED HUSBAND FATHER AND GRANDFATHER
DOMINIC SPALLIERO
1919 ✝ 1963

BELOVED WIFE, MOTHER AND GRANDMOTHER
DOROTHY HELEN SPALLIERO
1918 ✝ 2003

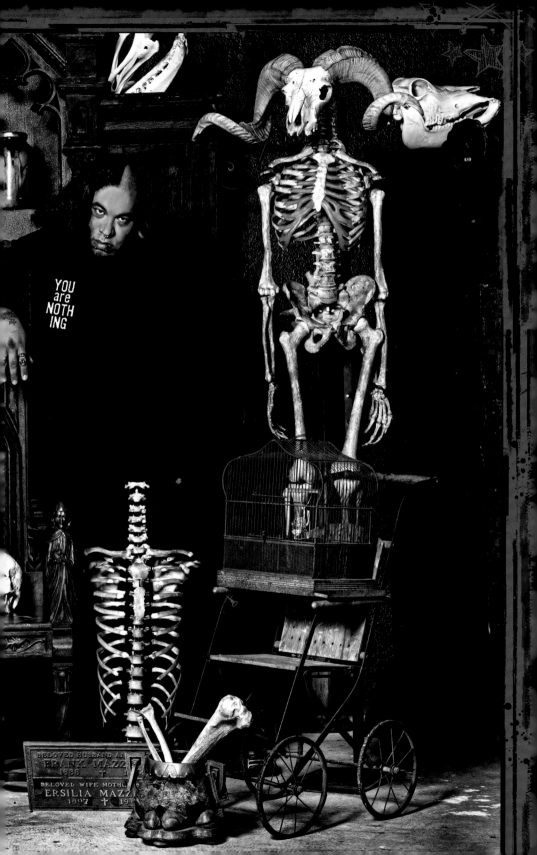

Remember that spirits of the dead are not our slaves to be bound and manipulated. In Haitian Voodoo this concept is called "bought Loa" sometimes referred to as zombi and are actually this form of bound spirit used for personal gain. It is said to never end well and is not advised in Voodoo. One sometimes refers to the fetch as going on an "Expedition" for a spirit to bind. This is not considered the correct way in traditional Voodoo and most houses frown on this quick fix for short term return type of work. The Loas and the exalted ancestors of our own family and House are there for you to serve. Spirits are our allies and will be protectors to help guide us.

If you keep actual bones, which is not a necessary part of Voodoo, just treat them with honor and put them in a special place. It is best to keep the bones on altars and to feed them with libations, tobacco, sweets, and personal items you feel they desire. You will develop a relationship with them and they will help you naturally if you treat them with respect, but also remember to set your boundaries with them. Ancestral altars with photos, representations of the dead, spirit statues, and offerings honoring La Morte and Ghede and La Grande Zombi are part of Voodoo service.

Always be aware of your own state's laws about owning bones and those of the areas you are travelling with them, for laws vary. Though it is legal in most states to purchase bones, it is always smarter to know the person the human bones belonged to. Maybe get your parents or grandparents to bequeath their skulls to you when they die (if you can convince them). Always remember that grave robbing is highly illegal everywhere.

"Animal bones are more used in Voodoo shamanism and trance work. We commune and work with animal spirits as familiars, spirit guides, messengers and transports. The bones of animals can be used to help your spirit animal and you to become one. Animal bones and skulls can be placed on an altar carried in a bag or worn as or on ceremonial garb or jewelry so as to always have them near to do ritual work on the move."

"In Voodoo, bones can be referred to as ju-jus and sometimes are part of gris-gris or mojo bags. Many fetishes and talismans are carved of bone, mainly animal bone. They are relics and considered animal medicine. Bones are your friends, You can throw 'da bones for a form of sortilege divination and even make music with them as you trance dance with them."

In Congo Square, New Orleans, Sunday Voodoo rituals in the nineteenth-century included voodoos playing the jawbone of the ass as part of the polyrhythm beat that called the spirits in. Or maybe you can just "Rattle dem bones" as an accent to mark the ending of an important segment. *Rat-a-tat-tat!*

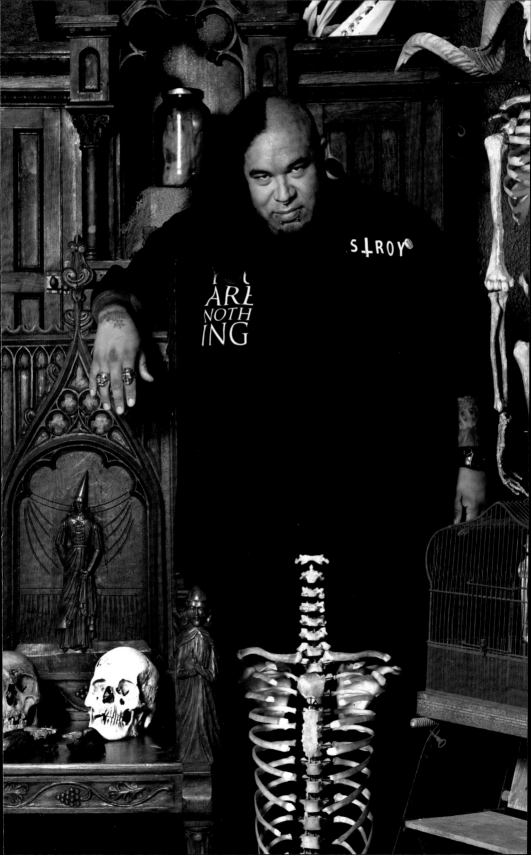

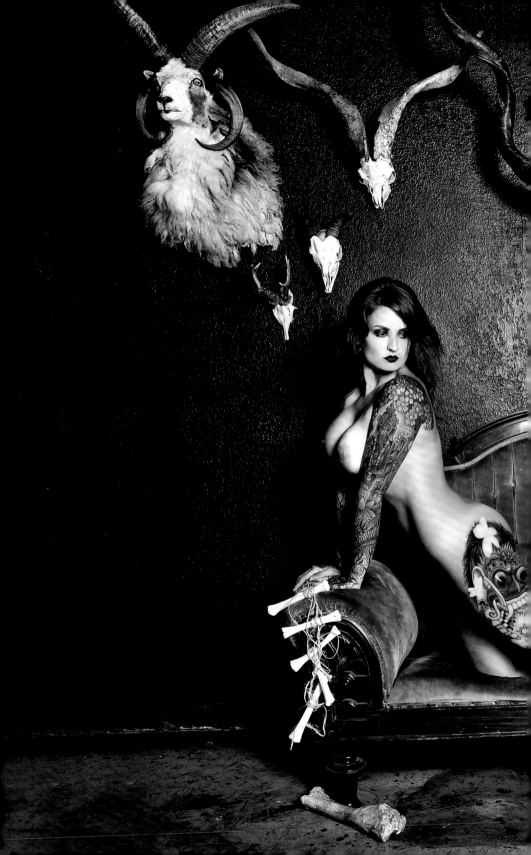

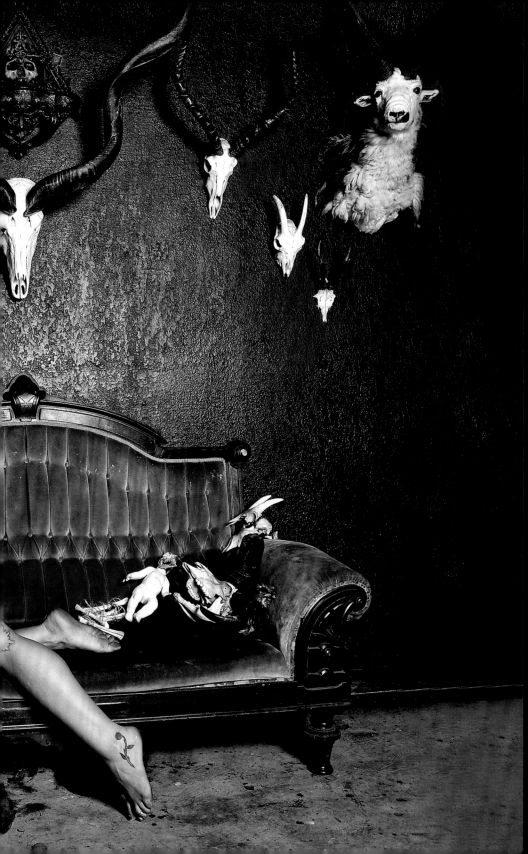

BARON & BRIDGETTE

ere is a power couple to be remembered, in fact one of the first power couples, or definitely the last. They dance with the dead because they are the dead. They are known as the Mother and Father of the bones. May I present to you the ever popular Baron Samedi and Maman Bridgette, his wife.

They are the history and the wisdom of all those that came before. They are the Lord and Lady of the cemetery. They can heal you, they can bury you: both are in their domain. First burials in cemeteries mark who's more in charge. If the first dead is a woman, then Bridgette is in charge; if male, then Baron is. Always look for the biggest cross in the place to check in with them. Salute both.

But just who are Baron Samedi and Maman Bridgette?

Baron is jovial, sexual, crass, sometimes rude, but also sincere. He is known to heal and has a fondness for protecting children. He is often seen with his top hat and his tailcoat, the undertaker's clothes, maybe adding a pair of shades with one lens missing. The top hat is the giveaway for a Baron visit, that and the dirty talk. Some confuse Papa Legba and Baron. They are separate, and are the opposite ends of the spectrum.

You can choose to remember Baron's wisdom as a godlike Egyptian guard of the dead, or you may look at him as a sexual grim reaper type. He is an important spirit to be saluted but just laugh at his vulgar attempts. He *will* get your attention. Be warned that he will point out your dirty little secrets so don't dare to play high and mighty with him. He is voraciously hungry. Feed him. He likes hot fiery peppered rum, bread, chicken, and spicy foods. He also loves sexy pictures (so he is all over Justice Howard's photo work). His day is Saturday.

> Baron is jovial, sexual, crass, sometimes rude, but also sincere. He is known to heal and has a fondness for protecting children. He is often seen with his top hat and his tailcoat, the undertaker's clothes, maybe adding a pair of shades with one lens missing."

Bridgette is about justice (the regular kind of justice). She also loves children. And when you want a situation solved fairly, one not handled in the physical realm, then plead sincerely to Bridgette in the graveyard. Pray. She handles many court cases, balances marriages when one goes astray, and delivers swift justice to those who are in the wrong. She listens intently but rarely speaks. Sometimes in ritual possession her chin will be tied up and her mouth stuffed with cotton like the dead.

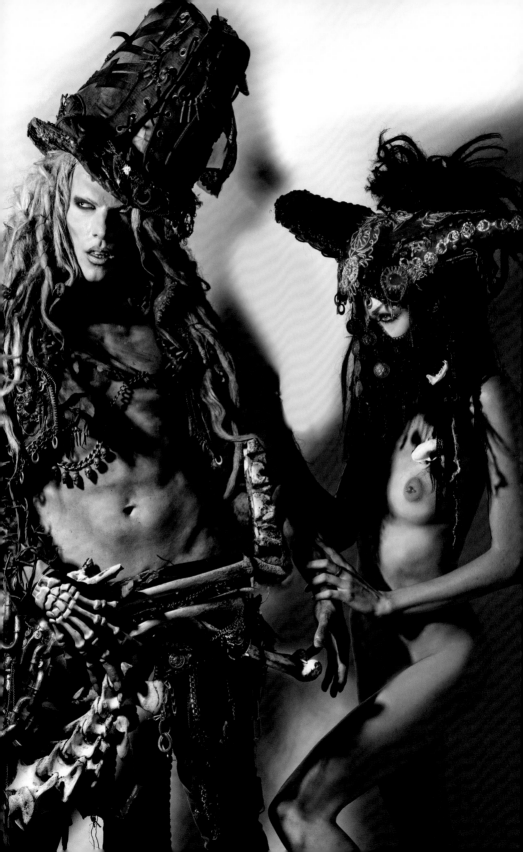

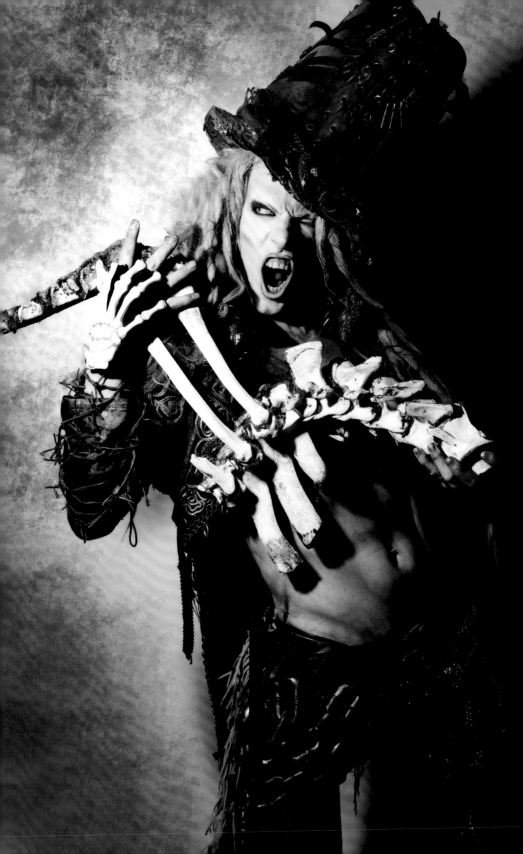

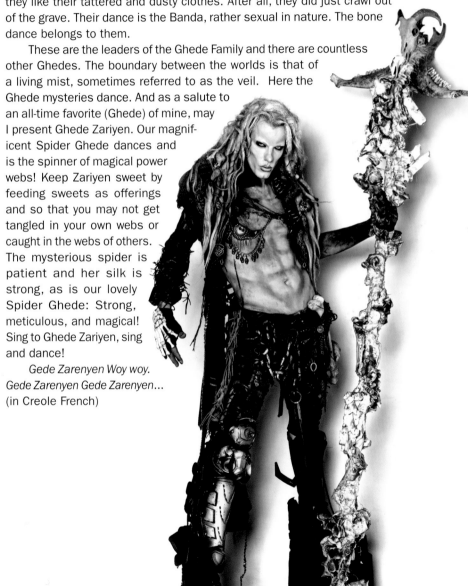

Sometimes she just sounds like it. She communicates more in visuals. Everyone's experience with a mysterie is unique and you may well hear her audibly, but most do not. Bridgette too likes spicy foods and chicken, preferably a black one. Maman Bridgette often has a pile of stones, a cairn, as part of her offerings altar. She is a spirit of transformation as she makes things right in the world. In this way she is like the smith part of Celtic goddess Bridgette, Saint Bridget, and she is evidence of Celtic-Afro connection in Voodoo.

Baron and Bridgette's colors are black and purple, the colors of mourning, and they like their tattered and dusty clothes. After all, they did just crawl out of the grave. Their dance is the Banda, rather sexual in nature. The bone dance belongs to them.

These are the leaders of the Ghede Family and there are countless other Ghedes. The boundary between the worlds is that of a living mist, sometimes referred to as the veil. Here the Ghede mysteries dance. And as a salute to an all-time favorite (Ghede) of mine, may I present Ghede Zariyen. Our magnificent Spider Ghede dances and is the spinner of magical power webs! Keep Zariyen sweet by feeding sweets as offerings and so that you may not get tangled in your own webs or caught in the webs of others. The mysterious spider is patient and her silk is strong, as is our lovely Spider Ghede: Strong, meticulous, and magical! Sing to Ghede Zariyen, sing and dance!

Gede Zarenyen Woy woy.
Gede Zarenyen Gede Zarenyen...
(in Creole French)

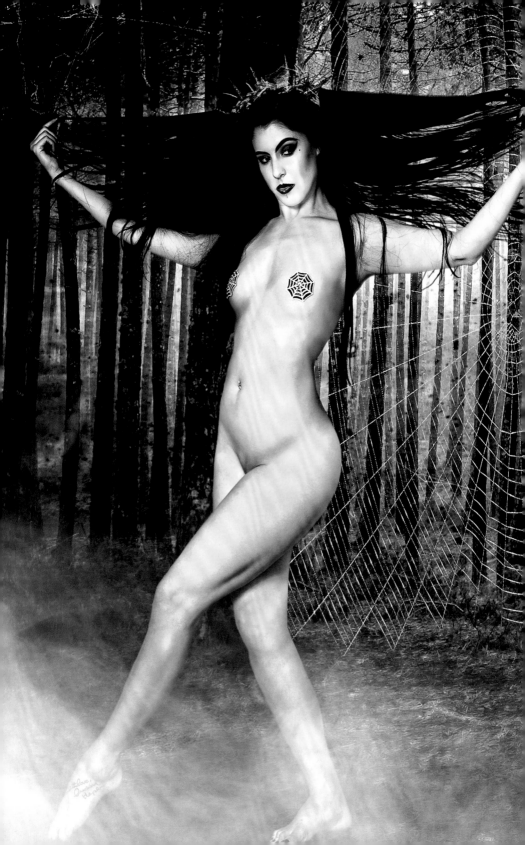

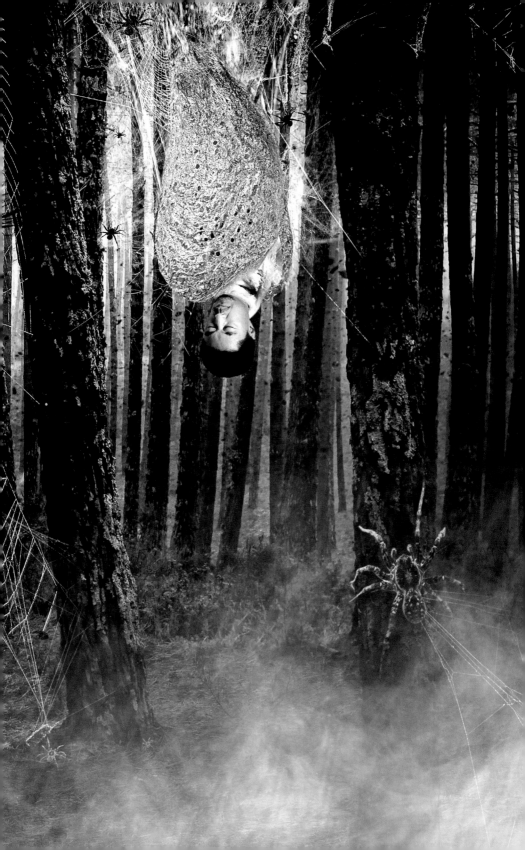

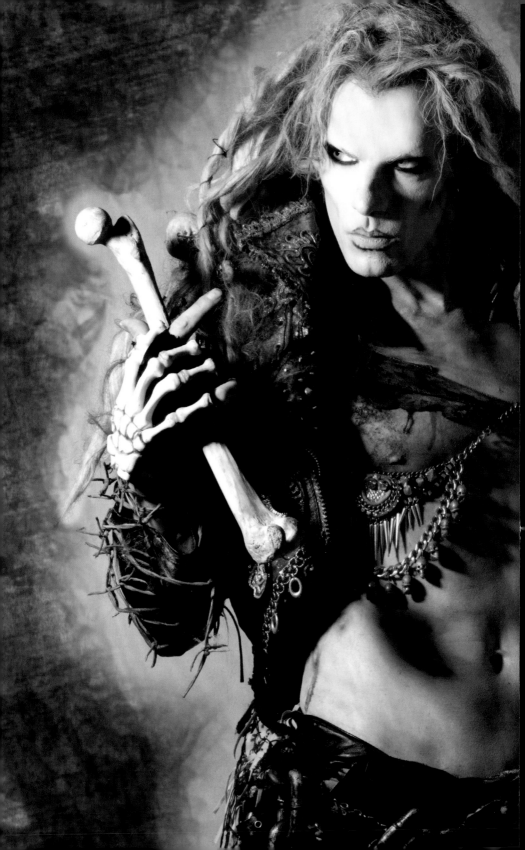

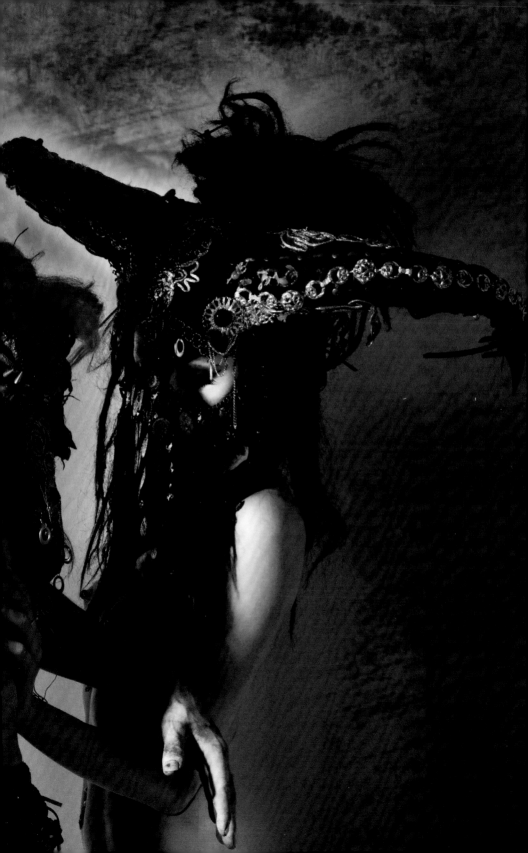

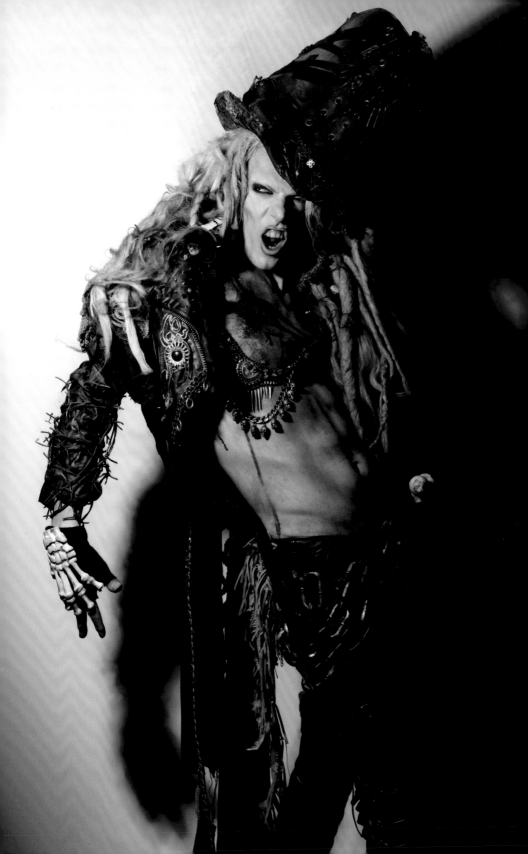

TRANCE DANCE POSSESSION

You should be aware that this is not a Hollywood-like possession but more like a trance medium. The host becomes the Loa. This can be more literal for some than for others. The interchange of spirit is a welcomed experience for most Voodoo practitioners, but some are afraid. Do not be afraid, but do not be in a hurry for this experience; build a foundation first. You become the spirit as the spirit steps into you. In many rituals we beckon the Loa to come in and we invite them to dance with us. You usually lose memory of the entire possessed state and sometimes you partially remember.

This trance dance possession is a desired goal in Voodoo ritual, and can manifest from many trigger sources. The polyrhythmic beat of the Voodoo drum, a visual stimulation, or even smells can be the catalyst for this outcome.

Tying knots in your hair as well as your own will can block the possession, and this is done purposely for protection for the neophyte or for those who are fearful. To let go of your guard, to let the ego slip away, can be a fearful thought at first.

Communication does occur in many different ways: dream possession can occur and, of course, wide awake possession occurs. You can fight it or you can let it in.

It is best to experience this Voodoo crisis in a ritual situation where the trained priests or priestesses can help you; so don't try this alone or at home.

BARON SAMEDI, THE GREEN-EYED SPIRIT

JUSTICE HOWARD

This all started when I decided to do a wild author photo for this book. I needed a crazy and never-been-done-before idea so I thought, "Why don't I make a necklace of real human teeth? That has never been done before and it will surely give people something to talk about." (Yeah, I know, I can't help it, that's just how my mind works!) I always say to people, "If you want something generic go to someone else."

Through my dark human body parts networking channels, I got the teeth and handmade this crazy necklace. Props at the ready, I set up my lighting and prepared to do my self-portrait. I was going for a kind of "crazy witch swamp lady" thing. The first photo that I did, a setup where the teeth are very visible and my face is clean, looks like me and works well for its purpose. But the second one is quite different.

After that first image was in the can, something in the room started to feel different. The energy changed and got really powerful. Since this is psychic shit, it's kind of hard to explain, but I will do my best. Someone was talking very loudly and plainly in my ear. But with volume so vociferous it was to the point of screaming through a megaphone. Like, boom box loud. This was a very male energy who told me to go and paint my face. Well, *he* was the one painting my face. It was all him and none of me. I actually *hate* polka dots and dots of any kind, and one of the mainstays of my art style is that I always keep the face clean. So this is not something I would normally ever do. (Later I found out that these dots are related to Voodoo, and are called Agassou. They relate to leopard spots, since the royal leopard represents the Ancestors and is a protector of honored traditions. Bloody Mary explains, "The spots are reminiscent of spirit diety Agassou who is depicted as a royal leopard. He represents the ancestors and is a protector of ancient honored traditions. He is *not* a leopard but the product of a divine mating of a leopard with a princess of Dahomey. He came over to the New World with the slave trade, to help Voodoo survive and protect the people."

So while I'm painting my face he is talking in my ear, very loud and very animated, like he is his own damn party, saying things like "This book is really wonderful . . . I love it . . . I love what you're doing . . . it's gonna be big"

What I felt most from him was his male energy and powerful spirit and his exhilaration, which was a super high-voltage blast. He was very, very fun, and my time with him was a riot. My energy is pretty high but his kicks mine to the curb.

He was with me for a good thirty minutes. He helped me shoot the second setup of my self-portrait, and was talking to me the entire time with an energy so high it was almost hard to keep up with. Then I went to wash my face paint off, and he was immediately gone.

Now at this point I'm kinda perplexed as to who the hell that was, and what had just happened. So I turned to my heavy hitter Voodoo Priestess Bloody Mary for answers. Mary told me, "I'm sure that is Baron Samedi. Being that your work is so

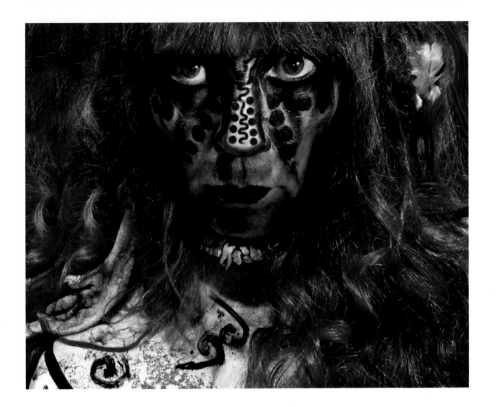

"Why don't I make a necklace of real human teeth? That has never been done before and it will surely give people something to talk about." (Yeah, I know, I can't help it, that's just how my mind works!) I always say to people, "If you want something generic go to someone else."

sexually oriented, it is even more obvious.-Baron is trying to come in and take over, which is what he does. He makes everything about sex; he makes everything a joke. Now some say the Ghedes and Barons are not Loas but something else. You see, most of the Loas don't like it when Barons are around. Barons really can only come at the end of ceremonies. The Barons are just too disruptive. Baron Samedi of course doesn't listen to this etiquette, but that is where he is relegated. Baron Samedi would be overly enthused about your work. He would love the nudity aspect and he would try to make it all about sex and death. After all, those are his domains. That was the definitive proof of who is trying to edit this book and dance with you."

When Mary gave me this info, everything fit.

Now comes the wicked wild part. I downloaded the files off my camera card and checked the self portrait shots. When I looked at the face-painted shots, I did not recognize myself in them at all. Well, basically because it wasn't me. The most unbelievable part is that in these photos I have ragingly bright green eyes. My eyes are actually brown.

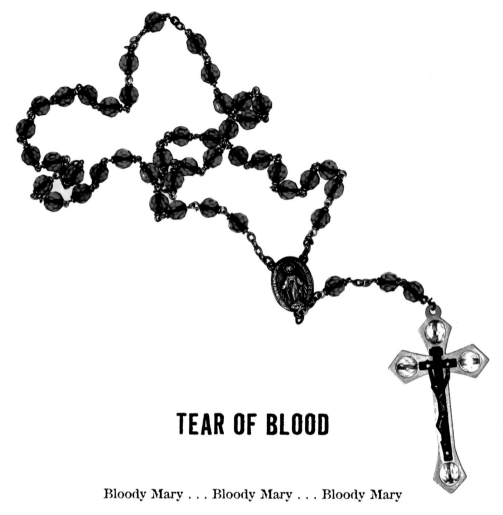

TEAR OF BLOOD

Bloody Mary . . . Bloody Mary . . . Bloody Mary

Light a candle, stare deeply into the mirror,
and say my name three times and I will come to thee!

Hence the folklore goes. I am Bloody Mary, she is Bloody Mary, you are Bloody Mary. She is not a ghost but a spirit in all women.

Come find out more from the flesh-and-blood Bloody Mary in New Orleans. Bloody Mary, New Orleans' Voodoo Queen, is a gifted storyteller, author, occult expert, paranormal investigator, and the curator and founder of the New Orleans Haunted Museum.

Real ghosts live in the Museum's 200-year-old creole cottage, where the spirits of New Orleans are honored, conjured, and connected with. See paranormal displays, interactive psychic games, the hall of altars, a paranormal photo gallery, haunted collections, and much more. Visit the Voodoo Pharmacy with its hands-on stations. Classes are offered as well. A special tribute to the Bloody Mary spirit also awaits you in the bathroom . . . see you there.

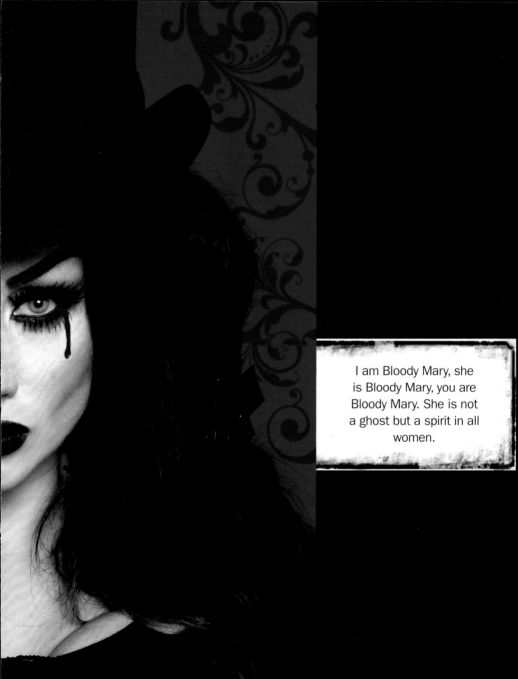

I am Bloody Mary, she is Bloody Mary, you are Bloody Mary. She is not a ghost but a spirit in all women.

BIBLIOGRAPHY

Bloody Mary. *Bloody Mary's Guide to Hauntings, Horrors, and Dancing with the Dead: True Stories from the Voodoo Queen of New Orleans*. Newburyport, MA: Weiser Books, 2016.

____. *Paranormal Bluebook: Spirit Guide to New Orleans Volume 1*. BMT Productions, 2012.

bloodymarystours.com/hist-neworleansvoodoo-htm/

ACKNOWLEDGMENTS

Special thanks to all of the Loas for being our protectors even though we couldn't cover everyone in this book.

Much gratitude to Robert LaSardo for flying in not once, but twice, from Seattle to work with me on this series.

Thank you to The Catalyst Butcher, my dark teddyscare friend Jeffrey, for use of the real human remains used as props in this imagery. All of the human remains featured in this photo series are real and the human skulls were used in Santeria rituals.

Kudos to Glenn Hetrick for allowing me to run amok in his F/X space and letting me use all of his wild-ass creepy props, and for trusting me to style him for this piece.

Huge props to The Boogeyman, the WWE Wrestler who flew to Los Angeles from Detroit to do these images, spending his one and only day in Lost Angeles working with me. I so loved being your "worm wrangler."

Thanks to K & M Edgecraft, blade makers extraordinaire, for a beautiful job on the custom machete created especially for this project for the Robert Lasardo photo.

Special Props of Badassery to my brilliant compositor Jeremy Gullotto who worked his graphics genius on these images. This series would not have been as phenomenal without Jeremy's assistance. Thank you for sharing my vision and crushing it.

Thanks Michael Godfrey for your glamour graphics on two of these setups.

Ghede Zariyen graphics were done by Jules of EV36.

Lovely Laura, you are always in my camp helping me pitch my tent onto a greener grassier more beautiful spot.

Thanks to Vannatter for his tireless endeavors as "the guy who gets things done."

Thanks, Baba Austin, for painting Angel Dies's naked body with the Ve-ves, and for the puddle of drool you left behind.

Thank you, John and Bree Guagliardo, for the pig's head. You raised him from a wee piglet and now he is forever immortalized in art.

Thank you, Shurie Southcott, for making the Papa Legba hat.

Thank you, Missy Munster, who created Perish's seven-foot-high staff from real animal bones.

Perish's clothing, hats, and headpieces were all made by Perish.

Ugly Shyla created the Erzulie Dantor doll.

Machetes from Ogoun, the Loa of metal, made by Carmack Designs.

Thanks Jagger for your editing skillz for accuracy.

Thanks to Gratz April Thompson, the wizardess hair magician who helped me weave chicken feet and other assorted nastiness into my hair for my "swamp witch" self-portrait author photos.

Thanks to Jonny Thief of Seppaku Tattoo for the illustrations of Bloody Mary and me.

For the original snake art, thank you, Cornfed.

Thanks to Jackpot the marvelous ten-world-champion Friesian horse, and his owner Julie, who helped make the book release party happen.

MODELS:

Glenn Hetrick *(pp. 22, 23, 24, 25)*
Robert Lasardo *(pp. 29, 31, 66, 67)*
The Boogeyman *(p. 93)*
Amy Nicoletto *(p. 89)*
Malice *(pp. 50, 51, 53, 54, 55)*
Tish Marie *(pp. 34, 49, 52)*
Navarone Garibaldi *(pp. 40, 41)*
Catalyst Butcher *(pp. 61, 69, 70, 71, 73)*
Ali *(pp. 17, 18, back cover)*
Angel Dies *(pp. 13, 57, 63, front cover)*
Perish *(pp. 77, 78, 79, 82, 83, 84)*
Morpheus *(pp. 19, 21)*
Pamela & Bat *(p. 47)*

Bat *(p. 65)*
Josef Cannon *(p. 21)*
Karen De La Creep *(pp. 44, 45)*
Anninka *(pp. 33, 36)*
Lizabella *(pp. 74, 75)*
Miss Reign *(pp. 29, 37, 42, 43)*
Harley Harpurr *(pp. 80, 81)*
Josi Kat *(p. 39)*
Julia West *(pp. 90, 91)*
Irene Silver *(p. 35)*
Jesse Jean *(p. 28)*
Justice Howard *(pp. 59, 87)*

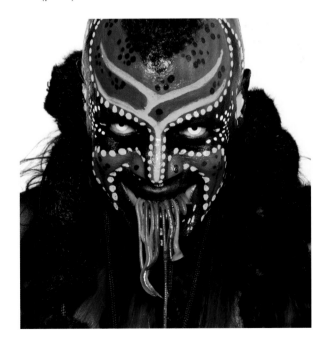

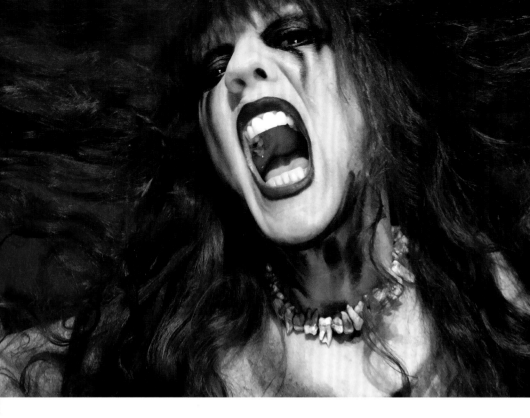

Internationally renowned photographer **Justice Howard** has been featured in numerous museum exhibits, thousands of articles, more than sixty art gallery exhibitions, and over 600 magazine covers. Her work graces books and magazines that stretch from *French Vogue* to *Easyriders*. Her classic photography, in both nuclear color and black and white, has captured some of entertainment's top icons. Penn & Teller, Waylon Jennings, Willie Nelson, Dick Dale, Marilyn Manson, Sonny Barger, Dave Navarro, Adam Rifkin, Mamie Van Doren, Elvira, Slim Jim Phantom, the Reverend Horton Heat, Lou Ferrigno, John Gilmore, and the Blue Man Group are just a handful of the celebrities who have spent time in front of Howard's lens. The upscale Lord Balfour Hotel in Miami showcases her thirty-foot wall murals in sixty-four of its rooms. Her photos have been described as "visions that are visceral and razor sharp, murderously vibrant, supernatural and intense."

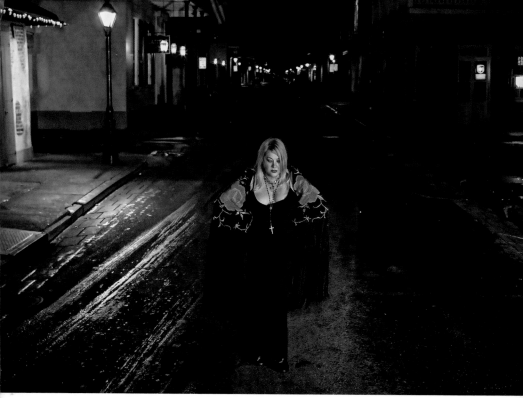

Pamela Reed photo.

Voodoo priestess and occult expert **Bloody Mary** is also a television celebrity who has appeared in over 200 international documentaries. She has been interviewed in thousands of articles and is an author, medium, ghost hunter, and the curator of the New Orleans Haunted Museum and Voodoo Spirit Shop at 826 North Rampart Street in the French Quarter. She is the author of *Bloody Mary's Guide to Hauntings, Horrors, and Dancing with the Dead*.

Other Schiffer Books by Justice Howard:

Revelations: The Photography of Justice Howard, ISBN 978-0-7643-4798-6

Design concept by Mike Vannatter
Cover design concept by Justice Howard

Type set in Badhouse/ITC Franklin Gothic Std

ISBN: 978-0-7643-5518-9
Printed in China

Published by Schiffer Publishing, Ltd.
4880 Lower Valley Road
Atglen, PA 19310
Phone: (610) 593-1777; Fax: (610) 593-2002
E-mail: Info@schifferbooks.com
Web: www.schifferbooks.com

For our complete selection of fine books on this and related subjects, please visit our website at www.schifferbooks.com. You may also write for a free catalog.

Schiffer Publishing's titles are available at special discounts for bulk purchases for sales promotions or premiums. Special editions, including personalized covers, corporate imprints, and excerpts, can be created in large quantities for special needs. For more information, contact the publisher.

We are always looking for people to write books on new and related subjects. If you have an idea for a book, please contact us at proposals@schifferbooks.com.

**All photos in this book were taken with a
Hasselblad H4 digital camera with a 80mm 2,8 lens.**

Thanks to Shar from Hasselblad Cameras for being my technical Hasselblad heroine.